Iznik Pottery

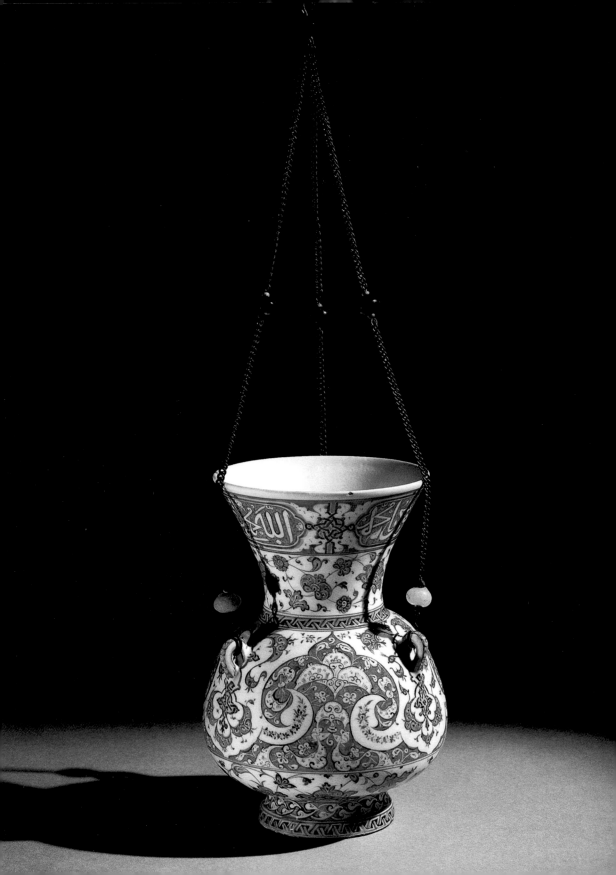

IZNIK POTTERY

John Carswell

THE BRITISH MUSEUM PRESS

For Peggy and Andy

© 1998 The Trustees of the British Museum

First published in 1998 by The British Museum Press
A division of The British Museum Company Ltd
38 Russell Square, London WC1B 3QQ
www.britishmuseum.co.uk

First published 1998
Second edition 2006

A catalogue record for this book is available from the British Library

ISBN-13: 978-0-7141-2441-4
ISBN-10: 0-7141-2441-9

Designed and typeset in Sabon by Martin Richards (New Leaf Design)
Printed and bound by Printing Express, Hong Kong

CONTENTS

PREFACE 6

INTRODUCTION 9

1 EARLY OTTOMAN CERAMICS 13

2 IZNIK BLUE-AND-WHITE 28

3 IZNIK AND KÜTAHYA 45

4 IZNIK EVOLVES 56

5 THE PEAK OF PERFECTION 74

6 IZNIK, CHINA AND THE WESTERN WORLD 90

7 THE COLLAPSE OF THE KINGDOM 106

8 LATER 114

FURTHER READING 121

MAP 123

ILLUSTRATION ACKNOWLEDGEMENTS 124

INDEX 125

PREFACE

The roll call of those who have helped to shape this book stretches back many years, in fact ultimately to Arthur Lane, who inspired me to write my first work on Turkish pottery. Also quite early on I met Professor Oktay Aslanapa in Istanbul, and he encouraged me by inviting me to publish my first article on the subject, in his university's *Sanat Tarihi Yilliği*. As I have related a little further on, I did not come to Iznik directly but rather through the back door of the Kütahya pottery industry, and faced with an epigraphic problem beyond my competence, it was Charles Dowsett who solved my quandary and in the process became one of my oldest and best friends. Basil Gray and Gerald Reitlinger were also key figures in steering my juvenile enthusiasm in the right direction. It was also about this time that an even younger acolyte knocked on *my* door; this was Julian Raby asking me, of all things, how to photograph Iznik dishes! Julian and I have been on the same track ever since, though admittedly he is now many leagues ahead. Walter Denny, whom I first met at the most civilised Turkish art symposium I ever attended, at Aix-en-Provence in 1976, has also been most helpful over the years. So has Esin Atil, then at the Freer Gallery in Washington, DC. On the minus side I must include the monks of Mount Athos, who proved to be a real thorn in the pursuit of pottery on their peninsula; but their objection to my investigations was religious, rather than art-historical.

Godfrey Goodwin was the first serious critic of anything I wrote and has been a generous mine of information ever since. So has Nurhan Atasoy in Turkey, accompanying me on expeditions to Edirne and solving all sorts of intractable problems. Faruk Şahin in Kütahya shared his invaluable technical knowledge with me, and indeed I owe a long-standing debt to the modern artists and potters in that town who have showered me with their

products. Sevgi Gönül also helped me concentrate my mind on the relationship between Iznik and Kütahya by kindly inviting me to contribute to the catalogue of Ottoman ceramics in the Sadberk Hanım Museum in Istanbul. Yanni Petsopoulos helped me formulate my thoughts coherently by inviting me to contribute to his early volume of Turkish decorative art. In Athens, Helen Philon, then at the Benaki Museum, spurred me on by asking me to catalogue the magnificent Iznik collection. She also arranged for key pieces to be tested, and this was carried out by Mike Tite, then Keeper of the Department of Scientific Research at the British Museum. Michael Rogers, a formidable critic, has pointed out my errors with a friendly hand; this work owes much to his generosity, as it is a precursor of his own detailed catalogue, eagerly awaited, of the Godman collection.

At the British Museum, I am most grateful to the Keeper of the Department of Oriental Antiquities, Robert Knox, for his blessing on the project; and to Sheila Canby, Assistant Keeper, for arranging for it to go ahead. Rachel Ward and Venetia Porter have also given me every assistance, as have John Williams, Dudley Hubbard and Kevin Lovelock, who took quite outstanding photographs of many key pieces. At the Press, I join the long line of admirers of Nina Shandloff, who skilfully edited the text and saw it to completion. Also in the museum world, I must thank my old friends Daniel Walker at The Metropolitan Museum of Art in New York and James Allan at the Ashmolean in Oxford for their help over the years. Tim Stanley has deepened my understanding not only of the complexities of Ottoman inscriptions but also of their historical and social context. John and Berrin Scott have been keen supporters of anything to do with my work in Turkey, and it is thanks to them and *Cornucopia* that I have been able to use one of Simon Upton's superlative photographs. Charles Dowsett, whose help I solicited once more rather late in the day, kindly supplied me with incisive translations of four Greek inscriptions. I am also most grateful to Philippa Glanville at the Victoria and Albert Museum in London for her swift advice on a particular point.

When it comes to the Chinese component, no one has been more gracious and helpful than Regina Krahl. And I must acknowledge a great debt to Sotheby's, my employer of the last ten years, for the enlightened way in which I was allowed to carry on with my research while going about my commercial concerns. Much of what I have learned about Iznik in the past few years has been due to the chance to handle and catalogue many extraordinary pieces that passed through their hands. I would particularly

single out Julian Thompson, Colin Mackay and Brendan Lynch, and especially the young men in the photographic department.

Most recently, I must thank Godfrey Goodwin, Michael Rogers, Sheila Canby, Venetia Porter and Julian Raby for responding to the thankless task of reading the manuscript and for their most valuable comments. At this point, all husbands thank their wives for putting up with them during the writing of the book (it never seems to work the other way round; perhaps wives manage two tasks more efficiently). I am no exception, and I am ever indebted to Peggy for her cheerful assistance.

Rereading the list of names above, one thing struck me: they are all my best friends.

INTRODUCTION

The British Museum is fortunate in having one of the greatest collections of Iznik pottery in the world, far greater than any in Turkey itself. How this came about reflects the changing pattern of taste, not only in Turkey during the last days of the Ottoman empire, but also abroad, where the eyes of a discerning group of individual collectors lit upon the splendour of Iznik pottery and tiles, so unlike anything else produced in either East or West. One of these superlative collections, made by Frederick DuCane Godman, was bequeathed by his two daughters to the British Museum in 1983, complementing its existing holdings so that the Museum now possesses an unparalleled range of Iznik ceramics. For this reason it is relatively easy to write a general history of the Iznik industry over two centuries or so, drawing almost entirely on examples from the British Museum.

If lacking in a collection of Iznik pottery of comparable importance, Turkey redresses the balance through the survival of a number of key monuments, mosques, tombs and palaces which are lined with dazzling examples of Iznik tiles. Indeed, the production of both pottery vessels and tiles in the same town, even perhaps in the same workshops, meant that there was an interaction in the designs of the two categories, one intended for the ornamentation of plain surfaces and the other to fill a three-dimensional space. The tiles are often part of the fabric of precisely dated buildings, and therefore supply valuable evidence for the evolution of the Iznik industry. Further clues are provided by inscriptions and dates on a few examples of pottery, by Ottoman documents and inventories detailing the economics, patronage and ownership of Iznik, by travellers' accounts of what they saw, and even by the testimony of Iznik pottery which itself travelled far afield, to grace the tables of European nobility

set with silver-gilt mounts, or the mess of Ottoman troops serving in a fortress on the Nile, on the frontier of Nubia.

Iznik today is a sleepy little town lying on the north shore of the lake of the same name, a hundred kilometres or so south-east of Istanbul. In earlier times it was an important Byzantine town with its own cathedral, the ancient Nicaea of the Christian creed, and it flourished due to its position on one of the main trade routes across Anatolia from the East. It was one of the first centres occupied by the Ottoman dynasty in the late thirteenth century, but achieved real distinction at the beginning of the sixteenth century with the establishment there of the Iznik pottery industry. The particular fascination of Iznik lies in the fact that, while in itself representing a technical innovation in the history of Turkish pottery, at the same time it symbolises the extraordinary combination of external influences from China and Central Asia, and even from Europe, which were the ingredients of the Ottoman style. But instead of producing a predictable eclecticism, the end product was something so unique and original that its impact is as striking and fresh as when it was first produced. If one is to generalise, broadly speaking Iznik moves from a tightly controlled first phase of monochrome blue ceramics to the addition of turquoise and a whole galaxy of subtle colours and a loosening of style, until by the second half of the sixteenth century there is an accentuation of colour and stridency with the introduction of a brilliant, impasted red. By the seventeenth century the sense of overall control diminishes, as has been suggested, as a result of the weakening of Ottoman power and patronage as a whole. But this final phase is not without its own interest, for other players and patrons helped to keep the industry alive.

At this point I should confess how I myself became interested, and later deeply involved, in the study of Iznik pottery. Many years ago, I discovered a series of tiles depicting scenes from the Old and New Testaments tucked away in the recesses of the Armenian Cathedral of St James in Jerusalem. Primitive in design and execution, they none the less had a Matisse-like vitality which intrigued me, and on my return to London I showed some photographs I had taken to Arthur Lane, who was then Keeper of Ceramics and Glass at the Victoria and Albert Museum. He told me that they were made at Kütahya in Turkey, another pottery-manufacturing town, which came into its own in the early eighteenth century after Iznik declined and finally became extinct. I asked him why nobody had published anything about the tiles, to which he promptly replied, 'Why don't you?' Thirteen years later,

I finally produced a work, not only on the pictorial tiles in Jerusalem, but on all the decorative tiles in the Cathedral and its dependent churches and chapels in the Old City of Jerusalem, and a corpus of all inscribed and dated Kütahya pottery throughout the world, as a basis for a comprehensive, chronological study of the Kütahya industry. This was published by the Clarendon Press at Oxford.

In the course of this exhaustive (and exhausting) task, I kept in contact with Arthur Lane, who, along with Basil Gray in the British Museum, became my mentor and provided me with much valuable criticism and advice, particularly about other collections and examples of Kütahya. I quickly realised that, while the decorative charms of Kütahya at its best had their own fascination, they were overshadowed by the far greater splendour of the Iznik pottery which preceded it. And, of course, Arthur Lane was the pioneer who first charted the history of Iznik, in a seminal article which appeared in *Ars Orientalis* in 1957. His study has provided the basis for all future research on the subject, my own included, and it is generally recognised that his analysis of the origins and development of Iznik is fundamentally sound.

1 Iznik across the lake, looking north through the trees, with the remains of medieval town walls on the right.

However much his conclusions may have been amplified by subsequent scholarship, his chronology is acknowledged to be correct.

However, there were two pieces of 'Iznik' which were crucial to his argument. Both bore dates and Armenian inscriptions which worried me, for both of them made mention of the town Kütahya. I asked Charles Dowsett, Professor of Armenian at Oxford, who had given Lane the original translation, if he could check them once again. He replied that they unequivocally referred to Kütahya, not Iznik, as their provenance. I hastened to consult Arthur Lane about this, but alas I arrived in London to find that he had just committed suicide, a victim of manic depression. To lose such a gifted and brilliant scholar, who had contributed so much original research to the whole history of world ceramics, was indeed a tragedy. It also left me in a quandary, for somehow I had to deal with these two aberrant pieces of pottery, both of which were at that time in the Godman collection. This knotty question is dealt with later in the present work.

The resolution of this problem stirred my interest in Iznik as a whole, and I began to appreciate its role as a precursor of the later pottery. This coincided with the documentation of over eight hundred pieces of hitherto unknown Chinese blue-and-white porcelain and celadon from Syria, mostly of the Yuan and Ming dynasties (fourteenth to seventeenth centuries), much of it of a type which clearly influenced the design of Iznik ceramics. Living in the Near East for over twenty years, I was able to follow in Lane's footsteps and seek out at first hand much of the Iznik evidence he quoted, not only in Turkey but also in Syria and Egypt. Besides Lane and Basil Gray, my debt to other scholars in Turkey and indeed all over the world is enormous, which should be evident from the works cited under Further Reading. Finally, all subsequent research since 1989 can only be a pendant to Nurhan Atasoy and Julian Raby's detailed and comprehensive study of Iznik, which accompanied the magnificent exhibition held the same year at the Ibrahim Pasha Museum in Istanbul.

Since this work was first printed I have catalogued the collection of Iznik ceramics in the Qatar National Museum in Doha, and the Iznik pottery and tiles in the Benaki Museum in Athens. While neither substantially affect the present text, they amplify it with much new and fascinating material.

1

EARLY OTTOMAN CERAMICS

Iznik pottery did not spring on to an empty stage. Anatolian Turkey has one of the oldest traditions of the manufacture of fired earthenware in the world, stretching back almost ten thousand years towards the end of the last Ice Age. Excavations by James Mellaart at Çatal Hüyük near Konya revealed that, in the seventh millennium BC, its inhabitants not only produced pottery but also powerfully expressive figurines of fired clay; at the same time, the remarkable painted interiors of their plastered houses showed a strong decorative sense. These qualities persist throughout the evolution of civilisation in Turkey, from the Bronze Age, the rise and fall of the Hittites, and the later domination of mainland Turkey by the Greeks and Romans, to the Byzantines and finally the Ottoman Turks themselves.

In the late thirteenth century, the Turkish tribes in north-western Anatolia, ultimately of Central Asian origin, of the house of Osman, formed the nucleus of a dynasty which was to last for over six hundred years, until the collapse of the Ottoman empire in 1919 and Mustafa Ataturk's creation of the modern Republic of Turkey. The Ottoman Turks were originally nomadic tribes operating on the fringe of the Seljuk empire of Rum and on the frontier with Byzantium, but their consolidation into a powerful political force led to their swift transformation into an urban rather than pastoral society. This did not mean that they entirely renounced their Asian heritage, and many symbols and customs from their past entered into everyday Ottoman life. Most significant was the Turkish conversion to Islam and, however much dictated by practical considerations, this also linked the Ottomans to the worldwide culture and economics of Islamic society, which by the sixteenth century they were to dominate in much of the Near East, southern Russia, eastern Europe and North Africa.

The urban process led to the Ottoman Turks establishing their first capital at Bursa, in 1326. Circumventing the Byzantine stronghold of Constantinople, in 1369 Sultan Murad I created a second capital at Edirne, on the European mainland, and finally Mehmed II captured Constantinople itself. Rather like the Umayyad early Islamic dynasty in the eighth century in Syria and subsequently in Spain, the Turks quickly adapted to the lands and society they conquered, while not entirely renouncing their nomadic roots. The great achievement of the Ottoman empire was to weld together all the different ethnic factions under one single centralised system, where minorities could be largely self-governing but still subservient to the ultimate power of the sultan. The most succinct expression of this was the Janissary corps, recruited from non-Muslim families at an early age and then given a superior education which allowed the talented to rise to the most important administrative posts. Under the Ottomans, everyone had a well-defined role to play, whether as a clerk, craftsman, butcher, baker or fireman. This is exemplified in the great processions under the direct sponsorship of the sultan, in which every possible profession, trade and craft would be represented.

Craftsmen, with their special skills, had value, and were one of the more useful spoils of war. This was particularly true of potters, who could be transferred from one end of the empire to another. An important early instance of this was the construction and embellishment of the Yeşil Cami (Green Mosque) and Yeşil Türbe (Green Tomb) in Bursa, late during the reign of Mehmed I (1413–21).

The Yeşil Cami is of T-shaped plan, and its most striking feature is the extraordinarily exuberant ceramic decoration of the interior. The walls are decorated with hexagonal tiles of plain turquoise, blue or translucent deep green, interspersed with turquoise triangles. The hexagonal tiles are further decorated with gold medallions, like great snowflakes floating away from the plain background. Above, there is an inscribed frieze running against a ground of spiralling arabesques, with a lower border of interlocking medallions. All these tiles are in *cuerda seca*, where the different elements of the design are separated by a dark outline (literally, 'dry cord') which prevents the areas of colour flowing into one another. The focus of the mosque, the great *mihrab*, is also decorated with *cuerda seca* tiles, with inscriptions running up one side, across the vault and down the other side; there are geometric and arabesque friezes, and at the centre a pointed, scalloped arch within which hangs an inscribed lamp

2

flanked by twin candlesticks, with a vase between them from which spring curving stems of lotus, peonies, lilies and other hybrid flowers, the spandrels and frame painted with interlocking arabesques. The three recesses at the rear of the mosque and the Sultan's loge above the entrance are decorated in the same technique; many of the tiles, like those on the *mihrab*, have been moulded before being glazed, so the whole ensemble has a three-dimensional element. This relates to the grand marble entrance portal, which has all the same decorative features, intricate relief inscriptions in cursive and more angular *kufic* script, arabesques and geometric friezes, all contained within a formal stone frame. Also on the outside of the building are wonderfully intricate carved marble lunette panels above the windows, contained within emphatic stone frames. And occasionally there are odd wedge-shaped turquoise ceramic insets, set flush with the marble facing.

Altogether the whole building and its carving link Bursa with Central Asia, to the mosques of Samarkand and the tombs in the Shah-i Zindah cemetery, as well as Timur's unfinished Aq Sarai palace at Shahr-i Sabz. Why? The clue is in an inscription in the Sultan's gallery, which records that the decoration was completed in AD 1424 by ʿAli ibn Ilyas ʿAli, or Nakkaş ʿAli. He was a native of Bursa, carried off by Timur in 1402, where as a master-craftsman

2 Hexagonal tiles with gold decoration, and above them a *cuerda seca* inscription and border tiles, *c.*1421, in the Yeşil Cami in Bursa.

he was exposed at first hand to the current Timurid style. Although the underlying sobriety of the mosque is typical of the emerging Ottoman idiom, the decoration is conspicuously Timurid. So is the technique, with its tile mosaic and sophisticated exploitation of *cuerda seca* and moulded panels. As for the tiles, they are signed twice, once on the columns flanking the *mihrab*, as 'the work of the masters of Tabriz' ('*amal-i ustadan-i Tabriz*), and again in the upper gallery by 'Muhammad the Mad' (*Muhammad al-majnun*). The reference to Tabriz is significant, for this is the town which produced a great exodus of artist-potters and tilemakers. Craftsmen from Tabriz are recorded in the tilework of Central Asia, and also in Syria and Egypt as well as in Turkey in the mid-fifteenth century. Although we do not yet understand why Tabriz played such a leading role in the evolution of Islamic tilework, the evidence of the craftsmen is still there to see, and the *nisbah* 'Tabrizi' indicates their pride in their city of origin.

Just across from the Yeşil Cami in Bursa is the Yeşil Türbe, the mausoleum of Sultan Mehmed I. The same band of Tabrizi craftsmen worked here too, for the tiled *mihrab* combines the same kind of *cuerda seca* elements as found in the mosque. But the most striking feature is Mehmed's cenotaph in the centre of the hexagonal building. With a sharply sloping top, it sits on a rectangular plinth decorated with an arcade in relief filled with stylised peonies. Above, surmounting a frieze of palmettes, are continuous bands of stately inscription against a floral ground, all in polychrome *cuerda seca*, including cobalt blue, turquoise, green, bright yellow and shades of pink and purple. The walls of the *türbe* are panelled with plain hexagonal turquoise tiles, as is the upper section of the exterior. There is a fine entrance, the tiles cut to fit once more a typical Timurid arch, of the pointed cloud-collar design popular during the Mongol ascendency all the way to China. And it is clear that the floral designs owe much to China too, both in the mosque and the tomb, although there is already the strong tendency to tidy up the Chinese designs and introduce a stabilising symmetry. Whether the *chinoiserie* was transmitted by the export of Chinese silks, lacquer or examples of Chinese blue-and-white porcelain, or even through painting, we do not know. More indigenous to the Islamic world are the candlesticks depicted in the mosque *mihrab*, of typical squat Timurid design, and the hanging-lamp above which must surely have been inspired by a Mamluk enamelled glass prototype. Here, then, in Bursa, the first Ottoman capital, in these two early fifteenth-century examples alone we already find many of the

4

3 OPPOSITE The carved marble entrance portal of the Yeşil Cami in Bursa, *c.*1421, in Timurid style, framed with *kufic* and *thuluth* inscribed bands. On either side are the brackets for arches to support a portico which was never built.

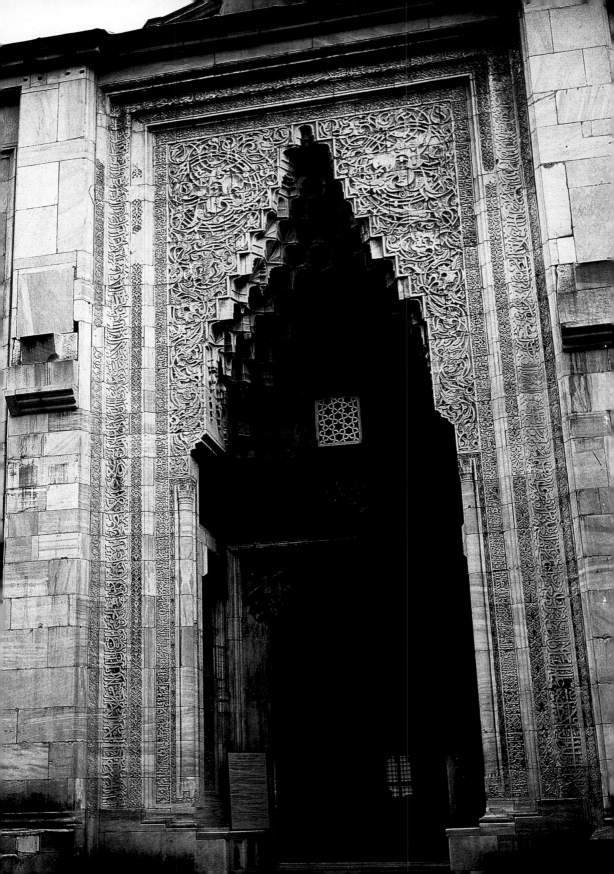

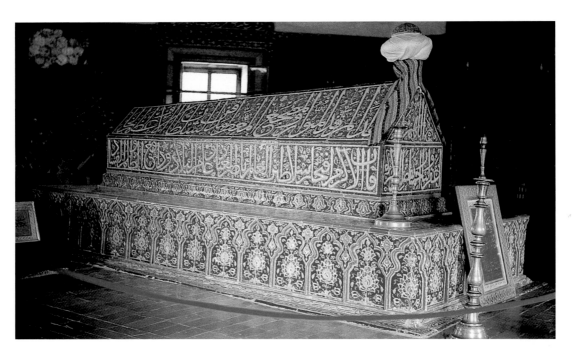

4 The cenotaph of Sultan Mehmed II (d. 1421), covered with *cuerda seca* tiles in relief, in the Yeşil Türbe in Bursa.

elements which were to be fused together into the Ottoman decorative repertoire.

The next link in the chain is to be found in Edirne, the second capital. Edirne, ancient Adrianopolis, was like Bursa an important town on the international trade network long before its conquest by the Turks. On the present-day frontier between Turkey and Bulgaria, it is the gateway from the east to the Balkans, which were also to contribute much to the emerging Ottoman state – in manpower, craftsmen and, most important of all, taxes. The city sits above the plain of the meandering River Tunca and its tributaries, and it was on this plain that the Saray, the royal palace, was constructed. Little remains of it now except a few foundation walls, the complex destroyed by fire and earthquake long ago. In the town, a mile or so away from its centre, is a small mosque dedicated to Murad II (1421–44; 1446–51), now stranded in a humble suburb. Again of T-shaped plan, it was originally a *zaviye*, the centre of a Mevlevi dervish complex, with rooms in the arms of the building for teaching and accommodation. The two domes are supported on a network of angular squinches, and the walls, now plastered white, show traces of wall-paintings below.

Entering this elegant but relatively modest structure, what is immediately striking is the great tiled *mihrab*, so obviously related in general design to the two *mihrabs* in the Yeşil Cami and

5

5 Detail of the *mihrab* vault of the Murad II mosque in Edirne, *c.*1435, decorated in underglaze blue and turquoise, including *chinoiserie* flowers and spiked, lobed leaves.

6 Three of the hexagonal tiles from the Murad II mosque, Edirne, *c.*1435, decorated in underglaze blue. The tile on the left derives from Chinese water-weed designs of the Yuan dynasty, the one in the centre perhaps from Vietnamese porcelain, and the tile on the right from early 15th-century Chinese blue-and-white dishes.

Yeşil Türbe in Bursa. Again basically constructed of *cuerda seca* moulded tiles, a continuous relief inscription runs up the sides and across the top, with an outer frame of moulded brackets, and a further inscribed panel at the top. There is a wide inner frame of geometric design, very like the kind of pattern often seen executed in interlocking sections of carved wood. The niche itself has elaborate polychrome spandrels, but it is the stalactite vault which is of special interest. Here, for the first time, a new technique is introduced, for all the carved elements are decorated in underglaze blue on a white ground. There are also touches of turquoise, and further inspection reveals that a few of the brackets of the outer frame on the right side are also partially painted in underglaze blue, and in one case in black under a turquoise glaze. The clearly experimental nature of these tiles indicates that the first essays in this novel technique took place during the decoration of the frame, and once mastered were used for the focus of the whole structure, the stalactite vault above the recess. The underglaze designs consist of stylised lotuses and camellia-like flowers on spiralling stems. This and the emphasis on blue-and-white, rather than the elaborate polychrome of the *cuerda seca* spandrels on either side and below in the niche, can only suppose a new familiarity with Chinese blue-and-white porcelain of the

5

early fifteenth century. Further, the inclusion of a spiked, lobed leaf (looking like a tiny lobster) would argue that the craftsmen had also looked at fourteenth-century Yuan blue-and-white ware, of which this odd leaf is almost a hallmark.

7 Related to the *mihrab* is a great tiled frieze on either side of it on the *qibla* wall and running down most of the north and south sides of the building. This consists of almost five hundred hexag-
6 onal tiles painted in underglaze blue, of fifty-three different types of design, interspersed with plain turquoise triangles. They are contained within a floral border and surmounted by a cresting of moulded palmettes, each with a raised pattern of interlocking arabesques reserved on a blue ground, with the sloping sides painted turquoise. Although also in underglaze, the moulding links the tiles to the relief decoration of the *mihrab*; it is thus part of a complete ensemble. The designs of the hexagonal tiles are extraordinarily varied; they combine elements drawn from Chinese blue-and-white porcelain of the Yuan and early Ming dynasty with further motifs which are more specifically geomet-ric and Islamic. With a very few exceptions, the general design of all of the tiles is based on symmetry, balancing the *chinoiserie* and geometric elements within each hexagon. One odd tile, however, is decorated with swirling feathery leaves around a single cypress, an image which must have been drawn from the water-weeds on a Yuan jar or dish. Many of the designs have six flowers on a spiral stem around a single flower at the centre; this is a
8 common design on early fifteenth-century Chinese dishes, although on the dishes there are usually five flowers, occasionally four, all different. What is oddest about these tiles of spiralling design is that many of them include the fourteenth-century spiked, lobed leaf, showing that the painters were drawing inspi-ration from more than one source. Half a century later, such a manipulation of motifs from different sources was to feature in much of the design of Iznik ceramics.

According to an inscription above the doorway, the Murad II complex was built in AD 1435/6, and it would be logical to ascribe the tiles to the same date. But here we encounter a snag, for it is clear that the tiles were inserted after not one but two layers of wall-painting had been applied. This can easily be seen at the north-east corner of the building, where the palmette frieze
7 shows the painted inscription running behind it, and later coats of limewash have fallen away. A further characteristic of the hexagonal tile friezes is that, in spite of the great variety of design, they are set in no coherent sequence. This haphazard arrangement is most clearly observed at the ends of the friezes on

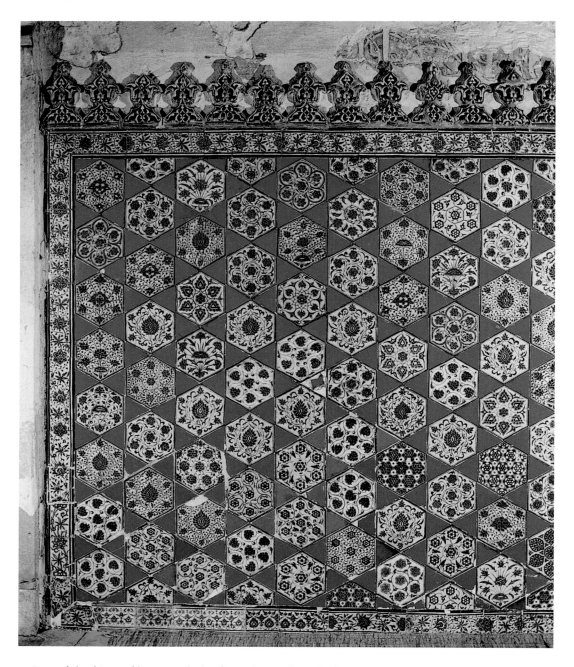

7 Part of the frieze of hexagonal tiles from the north wall of the Murad II mosque, Edirne, c.1435, decorated in underglaze blue. The tiles combine Chinese motifs of the 14th and 15th century. An earlier painted inscription can be seen above them, behind the moulded palmettes.

8 Detail of a Chinese blue-and-white porcelain dish, early 15th century, of the kind which inspired the tilemakers at Edirne. There are similar dishes in the Topkapı Saray collection. Ming dynasty, early 15th century. DIAM 38 cm.

the side walls to the rear of the main hall. Nor are the floral borders consistent, being of different types, although they link up in design with those on the bevelled sides of the *mihrab*. A further curious feature is the scale of the *mihrab* in proportion to the rest of the interior: it seems too large. Although dismantling part of the tile frieze to ground level would be necessary to prove it, archaeologically this would suggest that the whole tiled decoration was re-used from another structure. Although the date of the Murad II *zaviye* and the inscription on the *mihrab* to the same sultan does not invalidate the date of these tiles, it seems highly probable that they were moved from another imperial building, perhaps part of the palace complex on the plain below. This is not uncommon practise in the history of tilework, and it can be misleading to date tiles categorically by the date of the structure they adorn. It is also logical to assume that, if it was the same body of craftsmen who had worked in Bursa on the two most important royal buildings of the early fifteenth century, when they moved to Edirne a few years later they would also work on a structure of equal imperial status.

Technically the Edirne tiles show a further development aside from the introduction of underglaze: they are of an off-white earthenware, not the reddish clay of the tiles in Bursa. Spectro-

graphic analysis of two of the tiles has shown that they have a very high silica content. This change of body is again a precursor of Iznik pottery, which introduced a white frit material. The link with Persia is inescapable, for such a ware was already in use there in the thirteenth century, according to Abu'l Qasim's treatise of AD 1301. This would imply the stimulus of fresh ideas from Persia to add to the sophisticated use of *cuerda seca* by the band of craftsmen both in Bursa and Edirne. Nor, as we shall see later, was *cuerda seca* entirely abandoned in Turkey when the Iznik underglaze industry got underway in the early sixteenth century. But it appears that the fundamental shift towards the new technology took place in these tiles in the Murad II *zaviye*. It has been suggested that the hexagonal tiles can be linked to similar hexagonal tiles made and signed by a Tabrizi craftsman for the mausoleum of Ghars ad-Din Khalil al-Tawrizi, Governor of Damascus (d. 1430), and that these potters then moved to Edirne. But this is hardly likely for, although in the same general idiom, the Damascus tiles are crudely painted and set horizontally rather than on their points. One of the features of the Edirne tiles is the skill with which they were composed and executed, which for liveliness and sheer style it must be admitted excels the stilted refinement of the early Iznik blue-and-white. What the Tabrizi potters who worked in Syria had in common with those at Edirne was an understanding of the underglaze technique and the importance of a white body.

Finally, the adaptation of motifs from early Chinese blue-and-white implies the existence of actual Chinese porcelain in Edirne to be copied. For this we have no direct evidence, and when the first palace inventories were made at the end of the fifteenth century, after Mehmed II's conquest of Constantinople in 1453 and the construction of the Topkapı Saray, only a mere five pieces were recorded in 1496. But the Treasury records are misleading, for they give no indication of overall holdings. That there were many more at Edirne earlier in the century is speculation, but it is not improbable, and their impact on the local potters is a certainty.

There is one more building in Edirne which also supplies a further detail in the history of Turkish ceramics. This is the Üç Şerefeli mosque (1438–48), where under the arcade in the courtyard there are two inscribed panels of underglaze tiles. Sultan Murad II was the patron of this mosque as well, and the inscription on one of the panels reads: 'O my God, accept from the Sultan, Sultan Murad son of Muhammad Khan'. An abbreviated version of the same wording is in a cartouche at the bottom of the

8

9

great inscription framing the *mihrab* in the Murad II mosque, and is repeated again in mirror image at the bottom left of the *mihrab*.

Another link with the Murad II tiles is the running scroll of the border tiles, which turns up again on one of the Üç Şerefeli panels. The two panels are not the same, though similar in concept. On one of them the inscription is reversed, in white reserved on a dark blue ground, and the underglaze blue and turquoise are supplemented with manganese purple. Chinese elements include lotuses and peonies and thick and thin striped borders, a characteristic of the lotus panels on Yuan blue-and-white. One might also ascribe to fourteenth-century blue-and-white the idea of reversing the two panels, so that one is blue on white and the other white on blue. Another noteworthy feature is the fine spiralling stem behind the *kufic* and *thuluth* inscriptions, which with its coils and tiny hook-like leaves is surprisingly close in style to the spiral decoration of early Iznik pottery of the 1520s.

This leaves us with the interesting situation of a band of expatriate potters (although by now no doubt securely settled in Turkey), who had worked both at Bursa and Edirne in the first

9 Inscribed panel of tiles, decorated in underglaze blue and turquoise and dedicated to Murad II, under the arcade of the Üç Şerefeli mosque in Edirne, 1438–48. The borders are similar in style to those in the Murad II mosque (fig. 7).

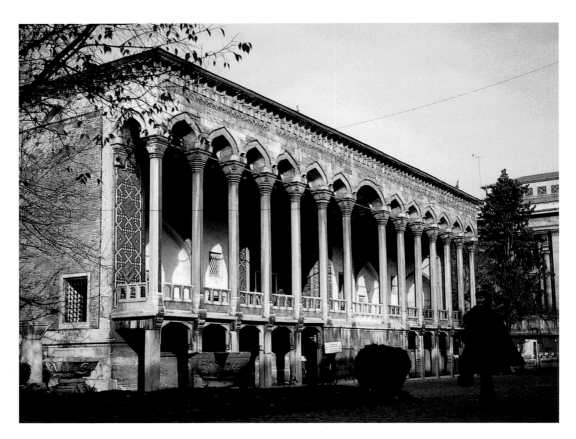

10 The façade of the Çinili Kiosk, 1473, with tile mosaic decoration. Part of the original complex at Topkapı Saray, the arcade was first a wooden construction in Timurid style.

half of the fifteenth century, and whose craft by 1435 shows a clear understanding of the technique of underglaze decoration as well as *cuerda seca*, both used for works of the highest aesthetic order. Obviously craftsmen need commissions to survive, and the question is what happened to them after Mehmed II came to power and established his capital at Istanbul. Mehmed was an avid patron of the arts, both indigenous and foreign; it was he, after all, who had the imagination to invite Gentile Bellini to spend a year at his court in 1479. It is hardly likely that he would ignore a team of master-craftsmen, with whose work he must surely have been familiar when he ruled as sultan from Edirne.

It is tempting to suggest that they moved to Iznik and were the foundation of the new industry at the end of the fifteenth century. But here there is a snag, for there is a gap of many years after they completed the Üç Şerefeli tiles. The possibilities are three: they either died off or abandoned their craft to adopt some other livelihood; they returned to Tabriz; or they worked elsewhere in the interim, of which there is so far little surviving evidence, except possibly some tiles in the *türbe* of Çem Sultan in the royal

cemetery at Bursa, and the panels in the Fatih Cami (1463–70) in Istanbul, decorated in underglaze blue, turquoise, green and yellow. The decoration of the Çinili Kiosk (1473), the first structure of Mehmed's new palace at Topkapı, is in tile mosaic and bears no relation to the Edirne style. As yet, we do not know what happened. The answer may simply lie in the nature of the potter's craft, for it is the potter himself who can travel and take his skills with him: provided the necessary materials are available, he can work anywhere.

2

IZNIK
BLUE-AND-WHITE

With no documentary evidence earlier than 1489–90 for Iznik pottery, in a palace kitchen register, we have no clear idea exactly when production of the new white fritware began. But there was an older pottery tradition at Iznik, and at this point it is relevant to examine it and to look at what was happening elsewhere in Anatolia. At the same time that the Ottomans were establishing their new dynasty in the late thirteenth century, in the south the Seljuks, ruling from their capital at Konya, were producing their own distinctive pottery. This included a hard white ware glazed in monochrome blue, turquoise, black or white, used to stunning effect as tile mosaic in a number of buildings at Konya and elsewhere in Seljuk territory. A similar white ware was used for pottery vessels, with simple underglaze designs in blue or green resembling those from northern Mesopotamia and Persia. A further link with the East was the large-scale production of star-and-cross tiles, some in the *minai* technique, which combined underglaze cobalt blue supplemented with lightly fired enamel colours. These were painted both with arabesque designs and with figural motifs, including seated revellers, harpies, double-headed birds and other animals. Numerous fragments of Seljuk ware have been excavated at Kubadabad, a vast Seljuk palace spectacularly situated on the southern shores of Lake Beyişehir west of Konya. The production of Seljuk ware appears to have lapsed in the late thirteenth century, for there is no discernible development.

Throughout Byzantium, eastern Anatolia, Cyprus and the Syrian coast, over several centuries, there had been a tradition of lead-glazed *sgraffiato* pottery. The earthenware body was masked with an opaque slip and decorated with incised designs, smudgily painted with loosely applied colours, most frequently amber or green. This kind of pottery had a wide distribution,

from Constantinople as far afield as Antioch, and as a popular style must have been made at many different centres. Locally made sherds have been excavated at Iznik. This is not surprising, as Iznik was situated on a major trade route across Anatolia from the east.

More important, recent excavations at Iznik have proved conclusively that it was the source of another well-known type of earthenware, referred to for many years as 'Miletus' ware because of its excavation in quantities from that site. With a reddish earthenware body and a white slip, it is painted under the alkali lead glaze in dark cobalt blue, and sometimes purple, turquoise or green. It has been found with kiln debris such as triple spurs, and provides the first evidence for Iznik as the major site for the production of this type of pottery. Most of the bowls and dishes have either plain or flat rims, and the majority are decorated in dark blue on the white ground. This immediately suggests a connection with Chinese blue-and-white, but with the exception of a few pieces with a stylised breaking-wave pattern on the rim, the designs do not seem to derive only from that source.

Many of the pieces are decorated with a central rosette and others with a cluster of fleshy spiralling leaves or a stylised diaper pattern. Some are painted with flying birds, six-pointed stars, or interlocking arabesque panels filled with tiny spirals. A characteristic feature is the use of rings of narrow radiating petals in the cavetto. These are often interspersed with panels of floral or abstract ornament, and with the radial designs often in more than one register. At first glance this might indicate inspiration from metalwork, but there is a far closer source for this particular design: Chinese celadon of the Yuan and early Ming dynasties, which is richly represented in the collection at Topkapı Saray. Here there are large bowls with the same basic design of tightly grouped radiating petal forms, although in the case of the celadon they are moulded rather than painted. They are also commonly used in two registers. Again, the celadon is decorated with central rosettes, fleshy leaves, diaper designs and key-fret patterns on the rim; all of these are also found on the Iznik wares. The origin of these designs is further confirmed by the find at Iznik, in the 1985 excavations, of a Chinese celadon sherd, actually carved with a fleshy pointed leaf.

From the same trench came fragments of a third type of locally produced earthenware. Here the reddish body is decorated with a thick, opaque slip, with designs of rosettes in a leafy ring, or arabesques. The ware is then covered with a transparent glaze,

tinted either green, blue or amber. A green-glazed sherd has a triple kiln-spur adhering to it, proving its local manufacture. This slip-decorated ware had a wide distribution throughout the Middle East and is part of a long-standing tradition in the Islamic world, as far afield as Nishapur in north-eastern Persia and in Central Asia at Afrasiyab near Samarkand. Again, it must have been made at many other centres besides Iznik.

These three types of earthenware, *sgraffiato*, underglaze-painted and slipware, were the immediate precursors at Iznik of the new white fritware sometime towards the end of the fifteenth century, and in all probability they continued in production as popular local wares after that date. The production of white-bodied tiles at Edirne in the first half of the fifteenth century has already been noted, but there does not appear to be any direct connection between the potters who produced them and the incipient Iznik industry.

Recent scientific analysis of the new Iznik pottery has revealed several interesting points. First, although the quartz-frit body is of the same general type as described by Abu'l Qasim in Persia in AD 1301, the body was made from ground quartz (between 5 and 12%, according to the clay used), to which was added small amounts of white clay and a soda-lead frit. The slip was also of quartz-frit type, but with far finer quartz particles, and mixed 3–8% of clay with 7–11% of frit. As for the glaze, it is of the lead-soda type, with a median lead content of 20–40%, and a significant amount of tin oxide (4–8%). The difference between the Iznik and other related Islamic pottery is that the quartz-frit body is finely textured, has a low iron content and stays comparatively white after firing; the slip is of even finer texture. The frit contains lead oxide as well as soda, and the tin oxide is in solution, producing a brilliant transparent glaze. Fifteenth-century pottery produced in Egypt, Syria and Persia in imitation of Chinese porcelain is technologically inferior to the new Iznik ware. Nor is there any correspondence between the Edirne tile-makers' technique, the latter using neither a lead frit nor a lead-alkali glaze. This leads to the conclusion that, however much the Iznik craftsmen were working within the general tradition of Islamic wares, they must be credited for a major innovation rather than the transference of an existing technology to Iznik. Finally, analysis of sherds of all types of Iznik and Kütahya ware of the sixteenth century, both monochrome blue and polychrome, and including wasters of early blue-and-white from Kütahya, shows that, with minor differences, the two sites shared a common technology.

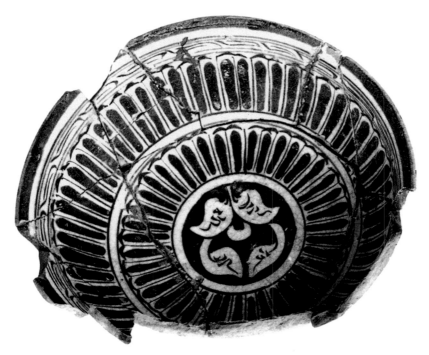

11 A fragmentary 'Miletus' ware bowl, excavated at Iznik, of reddish earthenware decorated in underglaze blue on a white ground, imitating a Chinese celadon prototype. DIAM 23 cm.

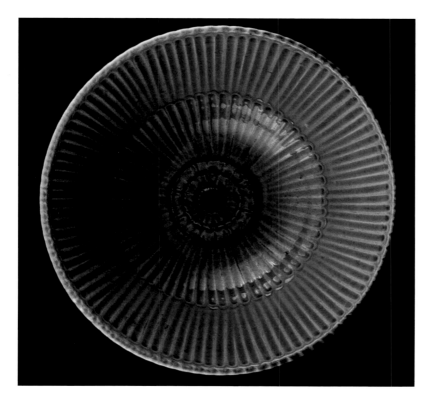

12 Chinese celadon bowl with radiating petal-like ribs, of a type commonly found in the Topkapı Saray collection. Yuan dynasty, 14th century. DIAM 43 cm.

31

As for firing techniques, we know little in detail, for the Iznik excavations have so far produced no firm evidence for the form and dimensions of the sixteenth-century kilns. The examples found have all been associated with the production of glazed red earthenware, and none contained any fritware debris. Nor have we any knowledge of how the Iznik tiles and vessels were stacked in the chamber above the firebox. Unlike the Miletus-type vessels, which were supported and separated by triple kiln-spurs, all one can observe about Iznik pottery is that the backs of the tiles and the footrings of the vessels are invariably unglazed. This implies that they were fired in some kind of saggar, or container, although again no trace of such apparatus has so far been found. Tests on Iznik ware have concluded that the firing temperature was in the range of 850–900°c.

If the new Iznik ware was novel, so was its shape and decoration. The early Iznik pottery, decorated in shades of underglaze cobalt blue, was introduced c.1480. The forms included large dishes, footed bowls, hanging-lamps, jars, candlesticks, hanging ornaments, flasks and even a pen-case. The style of painting, with its tight, interlacing arabesques and highly stylised floral motifs, often incorporating inscriptions (mostly illiterate), suggests an acute awareness of the current court style and the work of the *nakkaşhane*, the court designers and workshop. Many of the designs would have been more suitable for manuscript decoration than pottery. A whole series of large dishes is decorated in a deep blue, more ultramarine than cobalt, with densely conceived designs of arabesques and split leaves on wiry stems, almost all with the motifs reserved on a blue ground. The size of the dishes, about 40 cm (16 in) in diameter, evokes comparison with the only slightly larger Chinese blue-and-white dishes of the Yuan dynasty in the Topkapı Saray collection. The porcelain dishes show a similar predilection for designs reserved on a blue ground.

But if the Iznik potters were obviously aware of the Chinese porcelain, it is in the spirit of adaptation rather than imitation. Only one Chinese dish (TKS 15/1383) comes close in surface division to an Iznik dish. On the Chinese dish there is a central rosette within a ring of six radiating lotus petals, each with a flaming pearl, four cloud-collar panels with floral motifs inside a ring of eighteen lotus panels with Buddhist good-luck emblems, the cavetto has a wreath of peonies and the foliate rim is painted with a breaking-wave design. On the Iznik dish in the Louvre the general divisions remain the same, but the centre is transformed into a quadripartite arabesque design, with the ring of Buddhist symbols and the wreath in the cavetto reversed, the emblems

14

15

being replaced by an illegible Arabic inscription where the *alif*-like letter forms serve the same radial function as the lotus-panels; the plain rim is painted with a floral pattern. What survives is the overall white-on-blue tonality, sharply fractured by the wide white rings separating the different zones of decoration. The design at the centre owes nothing to China, and here the inspiration is from Europe rather than the Far East.

13 Balkan silver appears to have been popular in Ottoman Turkey, and several early sixteenth-century examples even bear the royal *tuğra*, or cipher, including one silver-gilt example with an enamelled plaque at the centre which belonged to Sultan Süleyman (1520–66). Many of the bowls have such plaques, which were prepared separately and then set inside the bowl with rivets, often fixed at the centre with a tiny silver rosette. The designs of these plaques consist of intricate arabesques with pointed half-leaves on spiralling stems, and such designs appear to have been a major source of inspiration for the Iznik potters, who created similar designs for the central panels of both dishes and bowls, even to the extent of replicating the silver stud.
23 Balkan silverware also furnished another motif, of radiating

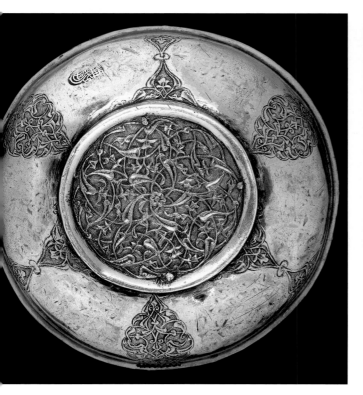

13 Ottoman silver-gilt enamelled bowl, with the *tuğra* of Sultan Süleyman (1520–66).
LEFT The base of the bowl, with finely chased and engraved decoration. The royal cipher is clearly visible.
ABOVE The enamelled plaque, fixed with studs to the inside of the bowl.

14 LEFT Chinese blue-and-white porcelain dish, with cloud-collar panels at the centre, Buddhist emblems, a peony wreath and a breaking-wave border with a foliate rim. Yuan dynasty, mid-14th century. DIAM 46 cm.

15 LEFT Iznik dish, *c*.1480, with an arabesque panel at the centre, a floral wreath and an unintelligible inscription, with a plain floral rim. The Iznik dish follows the general design of the Chinese dish (fig. 14) above, the ring of Buddhist emblems interchanging with the radial forms of the inscription. DIAM 44.5 cm.

16 Iznik candlestick, *c*.1480. HT 25 cm.
OPPOSITE The truncated neck has a silver mount, and panels of blue-and-white alternate with white-on-blue underglaze decoration.
BELOW Detail of the inscription, in *kufic* and *thuluth* on the lower body, which is unintelligible.

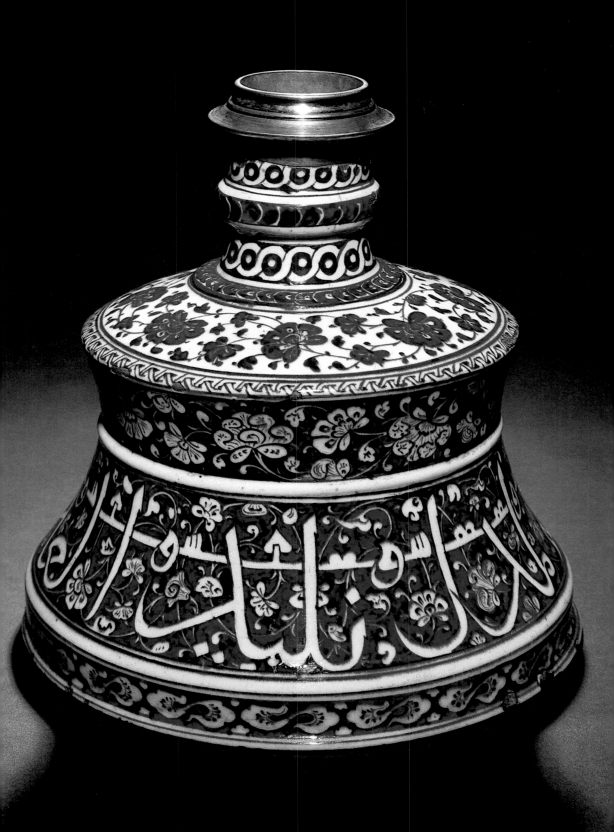

panels with either round or pointed tips and a central stripe. These derive from the repoussé panels on silver bowls. Little flowers on the early Iznik blue-and-white are very strange, with knobbly petals like boxing-gloves; they also have a silver parallel. The larger flowers are more obviously Chinese in inspiration; the lotus and the peony are flamboyantly treated, with sinuously curving petals each with a central tick, making the original Chinese flowers on Yuan blue-and-white look positively naturalistic by comparison. It has been suggested that the Iznik flora evokes the stylisations of the court designers rather than nature, and indeed all the works of this early group have a stilted feeling about them, as if they were designs dictated by artists with little sensitivity to pottery, more two- than three-dimensional in concept. It should also be noted that many of the inscriptions, though legible as individual characters, do not make any sense.

This is a feature of one of the most splendid objects in this series, a blue-and-white candlestick, painted with an impressive *kufic* and *thuluth* inscription which reads as total nonsense. This candlestick has a curious and continuing history. Known ninety years ago from an old photograph, it disappeared without trace only to resurface briefly in 1994, when it was sold at Sotheby's, thence to return once more to limbo; no one has any idea of its present whereabouts. But its short stay in the saleroom allowed it to be examined in the greatest detail. It is of typical Mamluk/Ottoman style, its metal origin showing in its angular form and raised mouldings. Again, it is white on blue, the blue-and-white kept for the upper, convex shoulder. There are more boxing-glove flowers, and novel motifs include two sorts of interwoven chain bands and a ring of S-shaped cloud-scrolls. The cloud-scrolls may have been a typically Turkish attempt to tidy up the Chinese motif, as it appears for instance on a dragon flask in Topkapı Saray (TKS 15/1391), or even a misapprehension of the Yuan serpentine wave.

Other members of this impressive if slightly overwhelming family of early Iznik, dating to the last quarter of the fifteenth century, include large *guan*-shaped jars, pilgrim-flasks and a hanging ornament now in Jerusalem. Perhaps at the turn of the century there is a perceptible lightening of style, and a fixed point is established by the blue-and-white tiles in the tomb of Şehzade Mahmud in the royal cemetery in Bursa, dateable to 1506–7. These are symmetrically designed, with tightly drawn flowers and split palmettes on an interlacing knotted stem and plain pointed medallions at intervals, where traces of gold leaf show they once had additional decoration. This use of large areas of

22

15

16

18

plain white ground, whether intended for extra gilt decoration or not, is a feature of this second group of pottery, consisting of large dishes, hanging ornaments and lamps, jugs and deep-footed bowls. Aside from the predominance of knots, suggesting the personal preoccupation of a single painter, other hallmarks of this group are diadem-like ornaments and flowers with tight spiral petals and little

17 hooked leaves which have been compared to tadpoles. The hanging-lamps of this group are all fairly bizarre, the inscribed panels (crudely but now legibly written) sitting uneasily on the form, in one case vertical on the body. Four lamps, once in the *türbe* of Bayezid II (d. 1512), and a pen-box, all in the British Museum, belong to this early category.

19 The pen-box, with its much later silver fittings stamped with the *tuğra* of Selim (probably Selim III, 1789–1807), is particularly interesting, as it combines on one object many of the stylistic features of this period of Iznik blue-and-white. The shape itself is of metal origin, following the general form and function of Islamic inlaid pen-boxes of the thirteenth and fourteenth centuries. It has been suggested that the idea of replicating the metal shape in ceramic is a Chinese one, for a number of porcelain copies of Islamic pen-boxes do exist, including a famous one with gold and bejewelled fittings in the Topkapı Saray collection. But the Iznik pen-box is quite different in design and layout, and even if the odd idea of reproducing a utilitarian Islamic metal object in pottery were Chinese (and there are other instances of this, notably an early fifteenth-century porcelain copy of a Mamluk inlaid metal stand, now in the British Museum), it is an independent development. Round the sides is an illegible and highly complicated *kufic* inscription, while on the top is part of a verse from the Qur'an (LXI, 13) in cursive script. Behind the side inscriptions a delicate spiral is traced, and above and below are borders of knotted chevrons; the ends are painted with split palmettes and knobbly flowers, the top with a knotty motif between the two wells. The base – like the bases of many contemporary hanging-lamps – is decorated with a swirling cloud-scroll flanked by diadems with vigorously drawn leaves and tiny flowers

17 Iznik blue-and-white base sherd, with spiralling tadpole-like leaves, early 16th century. Photographed in the garden of the Royal Palace in Athens.

37

on curving stems. The blue ground of the upper inscription is scattered with darker dots; this occurs naturally on Yuan and early Ming porcelain where the cobalt is applied too thickly, and this accident was incorporated into the decorative repertoire of the Iznik potters.

The same effect can be seen on a lamp in the British Museum (illustrated on the frontispiece), one of four hanging-lamps which can be considered a group. All are of identical form and dimensions, with flaring necks and squat bodies, and all have one or other of the features already noted on the pen-box. The British Museum lamp has cloud-collar panels of Timurid inspiration filled with diadems and cloud-scrolls, knotted devices linking the inscribed panels and the now familiar flowers and tadpole leaves, as well as chevron borders. All four lamps and associated bowls and dishes combine all these elements in different and ingenious ways, though not always successfully in relation to the surfaces they adorn. The impression is of a craftsman who was attempting to combine motifs from a variety of sources, the most obvious being manuscript illumination. Even more, one wonders if Ottoman book-binding did not play a part in stimulating his imagination; many of the elements are to be found in fifteenth-century bindings. For instance, knotted patterns are frequently used as borders, composed of the intricate stamping of one or more hook-shaped iron tools. A blue-and-white dish in Paris has 20 a central design of pointed medallions at right angles to each other, with rosettes between, which is closely related to the stamped leather doublures (inside covers) of a commentary on the Qur'an of the first half of the fifteenth century, now in Bursa. 21

18 ABOVE Iznik blue-and-white border tile, in the *türbe* of Şehzade Mahmud, 1506–7, in the royal cemetery at Bursa. The scalloped white medallions originally had additional gold decoration.

19 BELOW Iznik blue-and-white pen-box, c.1520, with later silver mounts bearing the *tuğra* of Sultan Selim III (1789–1807). The shape copies an early Islamic metal prototype. L 29.6 cm.

Whether arabesque, geometric or inscriptional, the essence of book-binding decoration is tight control of design and execution. These are exactly the qualities of this early sixteenth-century Iznik group, though the flat surface of a book cover is obviously more suitable.

Whether or not the potters consciously realised they were being defeated by the three-dimensional forms of the vessels, it is noticeable that the next step is a loosening-up of design. This can be seen in four more lamps, all of which evidently came from the tomb of Bayezid II (d. 1512) and a fifth, in the British Museum. The painting, particularly of the shaded flowers and lotuses, is

23

20 Iznik blue-and-white dish, *c.*1510, the centre decorated with pointed medallions at right angles to each other, with spiral rosettes and tadpole-like leaves (see fig. 21). DIAM 40 cm.

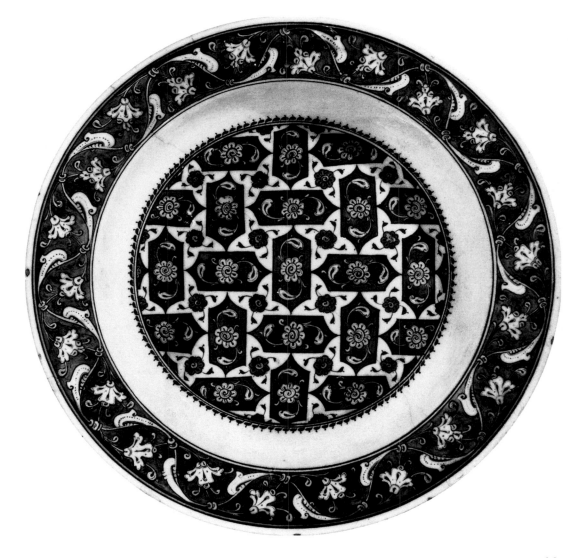

21 Detail of a leather doublure (see fig. 20), the inside back cover of Fakhr al-Din al-Razi, *Mafatih al-ghayb*, vol. II; before 1453.

much more assured. The implication is that the painter may have been paying closer attention to Chinese sources, however stylised the results. There is also a fresh motif – bands of elongated pointed panels with a central spine – which Julian Raby has pointed out have their inspiration in Balkan silver. As he also notes, there is no reason that these five lamps, rather different in style from the four previously discussed, could not all have been contemporary products, produced by two different craftsmen with quite different sensibilities; there is no reason to suppose any chronological development.

This leads one to ponder on the nature of the organisation of

22 Ottoman silver bowl, early 16th century, with incised and repoussé decoration, of the type which influenced Iznik designs such as the hanging-lamp (fig. 23). The bowl has a Greek stamp and Armenian inscription on the reverse. DIAM 16.7 cm.

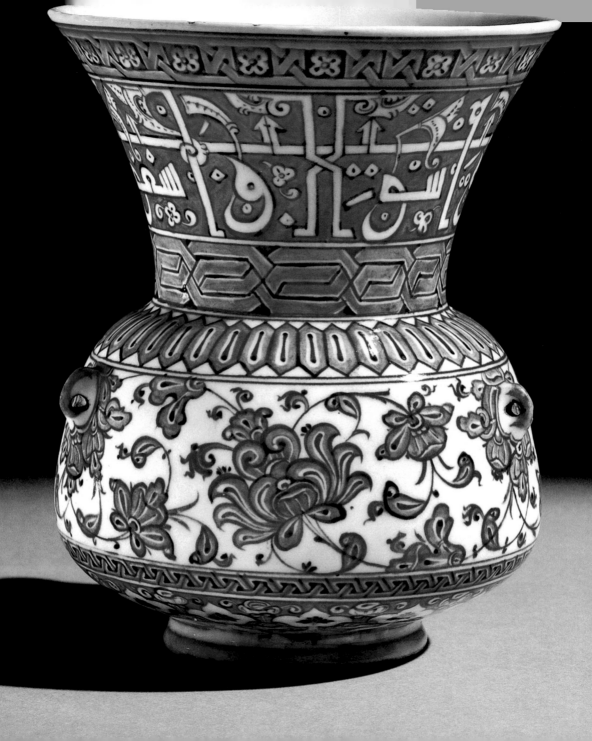

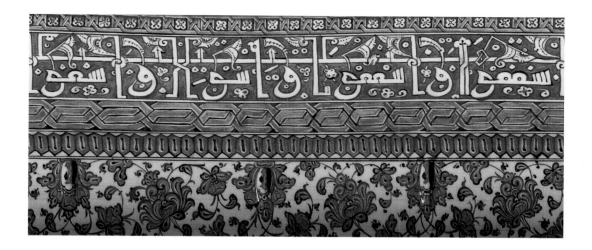

the workshops at Iznik, and exactly how they functioned. In the initial phases the industry must have been dependent on the specialised knowledge of a relatively few potters, who introduced the new technology. Why did this happen at Iznik? The answer is probably the existence of an already established ceramic tradition and, more to the point, the ready availability of materials such as fresh water, fuel, clay and minerals for glazing compounds. The white frit body was crucial, and as early as the seventeenth century we have the evidence of an English traveller, Dr John Covel, that just the right kind of clay was available close to Iznik. He visited the little town in the 1670s and, after remarking on its general decrepitude compared to the splendour of its Byzantine past, gives a detailed description of its monuments. He stresses that the present importance of the town is simply as a traveller's halt ('no trade but for horse furniture and travayling necessaryes') and that at the weekly Wednesday market there is:

no staple commodity of note there but your erthenware . . . digged out of pits on ye side of ye hills to ye E. about 1½ hours from town about *homarcui* [Omerli Köy] . . . this earth is whitish, very fine and mealy not gritty . . . to this they mixe that fine sand and then it burnes hard . . . then they paint them in what colours they please and afterwards glaze them, they come short of your common dutch ware; of that same earth they make dishes, pots, pitchers, Jarres etc. They are much used in Stambol; and ye pillars of *Valladeh jamy* [Yeni Valide Cami] are cased in this tile . . .

23 Iznik blue-and-white hanging-lamp, with decoration influenced by Balkan silver (fig. 22).
HT 22.7 cm.
opposite This lamp is one of five believed to have come from the *türbe* of Bayezid II (d. 1512).
ABOVE Detail showing the band of lettering on the neck. A suggested source is the phrase *wa-asu sahwan* [and they grieved distractedly].

Covel was describing Iznik a century after its peak period, when the industry was in swift decline. But the essential ingredients were still available; why the collapse came about will be discussed in its proper place.

3

IZNIK AND KÜTAHYA

24
25 When Arthur Lane wrote his article on 'The Ottoman Pottery of Isnik', two key pieces in establishing the stylistic development were in the Godman collection; both are now in the British Museum. One is a small ewer with a dragon handle and the second a cut-down flask. What they have in common, apart from being decorated in blue-and-white, are Armenian inscriptions on their bases, and the flask has a further Armenian text on the torus moulding, just below the point at which it has lost the upper part of its neck. Both texts contain specific dates, and both mention the town of Kütahya.

24 The ewer has a bulbous body, a narrow neck with a convex moulding, flaring to an almost vertical rim, a tall spout rising above the level of the rim, and a dragon-shaped handle with its mouth open and a hole where it joins the neck, suggesting there was also once a lid attached by a chain. It is decorated in shades of cobalt blue and, apart from the dotted scales on the dragon's body, in a clumsy but conventional early Iznik style. The body has interlacing stems reserved on a blue ground, with split palmettes whose prehensile tips clutch opposing stems, and crude versions of the boxing-glove flower. Below, there is a wreath of flowers on a white ground, and above on the shoulder a ring of tadpole leaves, crosses in an interlocking chain band, tall dotted panels with flowers between, and interlocking half-palmettes on the rim. The spout has an interlocking chain design with leaves on either side. Indeed, the general impression is that it was the work of a potter who had paid a not too careful look at one of the hanging-lamps already described, perhaps even the one now in the British Museum.

NTIS-
PIECE However, its importance lies in the inscription, written in seven lines of Armenian *bolorgir* script on the base; it reads:

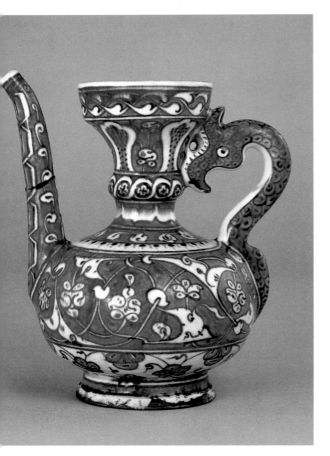

24 ABOVE LEFT The Godman ewer. Kütahya blue-and-white, inscribed on the base in Armenian and dated AD 1510. HT 17.8 cm.

25 ABOVE RIGHT The Godman flask. Kütahya blue-and-white, inscribed on the base and the torus moulding in Armenian and dated AD 1529. HT 23 cm (neck broken).

Yišatak ē
abrēham
caṙayi · a(stuco)y · kʿotʿ–
ayecʿi. say baž(a)k
aman s i̇ tʿvis
───
jctʿ mart
───
ža: –

Ցիշատակ է
աբրէհամ
ծառայի · ա͞յ · քոթ
այեցի: սայ բաժ(ա)կ
ամա՛նս · ի թվիս
────
ջ͞ձ͞թ : մարտ :
────
ժա :

This vessel is in commemoration of Abraham, servant of God, of Kʿotʿay [Kütahya]. In this year 959 [AD 1510], March 11th

The flask is in quite different style. With a pear-shaped body and standing on a sloping pedestal foot, it is painted in two shades of 25

dark underglaze blue. The body is decorated with tightly coiled spiral stems, with hooks at intervals and tiny leaves and flowers, with a chain band on the shoulder and tiny rosettes on a more relaxed spiral stem, with similar motifs above the torus moulding, which has an inscription in Armenian *bolorgir*; it reads:

T(ē)r Martiros yepiskaypos
xapar xrkecᶜi Kᶜotᶜayəs
s(ur)b A(stua)cacin jez barexaws
mēk surahi xrkēkᶜ i hos
barov bṙnē T(ē)r Martiros
i tᶜv(i)n ǰh marti žə grvecᶜ ays surahin

Տէր Մարտիրոս յեպիսկայպոս
խապար խրկեց ի քոթայըս
սը աձածին ձեզ բարեխաւս
մէկ սուրահի խրկէք ի հոս
բարով բռնէ Տէր Մարտիրոս.
ի թվ(ի)ն ՂՀ մարտի ժը գրվեց այս սուրահին

Bishop Tēr Martiros sent word to Kᶜotᶜayěs [i.e. Kütahya, here]: 'May the Holy Mother of God intercede for you: send one water-bottle (*surahi*) here.'
May Tēr Martiros receive it in peace. In the year 978 [AD 1529] on the 18th March this water-bottle was inscribed.

There is a further inscription in Armenian *bolorgir*, in a spiral design on the base:

Տէր Մարտիրոս խապար խրկեց յանկուռեայ էս սուրահի.
թող բան քոթայս սը աձածին վանքիս

T(ē)r Martiros xapar xrkecᶜ yAnkuṙeay ēs surahi.

tᶜoɫ ban Kᶜotᶜays s(ur)b A(stua)cacin vank ᶜis

Tēr Martiros sent word from Ankara: 'May this water-bottle [be] an object [of] Kᶜotᶜays for this monastery of the Holy Mother of God.'

47

Without rehearsing all the arguments for and against the provenance of these two pieces during the past half-century, Lane was convinced that neither of the vessels was actually made in Kütahya, but were the work of Armenian craftsmen at Iznik. However, Professor Dowsett, who has produced the definitive translation quoted above, has shown that the objects refer unequivocally to Kütahya, particularly the flask, which refers to itself as 'an object of Kütahya'.

This leads to a consideration of Kütahya as a pottery-producing town, and the origin of the ceramic industry there. There is no doubt that it flourished as such from the early eighteenth century onwards, with the Armenians playing a major role, and has continued to operate up to the present day under more specifically Turkish management. But what about its earlier history? Bearing in mind the evidence of the Godman ewer and flask of AD 1510 and 1529, there are records of an Armenian minority and their churches in Kütahya as early as 1391, and two more in the fifteenth century, one built in 1444–5 and the inventories of a second church dated 1485–6 and 1489–90. The second is of special interest as it was made for a deacon named Abraham who is described in it as 'the son of a potter' (*tchiniji*). There are plenty of records of Kütahya as a pottery-producing centre in the seventeenth century, and even earlier; the problem is to identify the product. The clue is contained in recent excavations in Kütahya itself, where sherds of blue-and-white in the early fifteenth-century 'Iznik' style, including a waster, have been found. So the question is resolved: at this time both towns were producing similar wares, a conclusion further confirmed by scientific analysis at the British Museum showing early Iznik and Kütahya ware are virtually identical in composition.

Kütahya is twice as far away to the south-east of Istanbul as Iznik, and did not have the immediate easy access to the capital that Iznik enjoyed, by pack mule to the little port of Karamürsel and then directly across the Sea of Marmara. In the final analysis, it is likely to have played a subordinate role to Iznik until the early eighteenth century when it came into its own. To return to the Godman pieces, the ewer simply serves to corroborate the date already established for this style of blue-and-white. This is also true for the flask, which helps to document another category of Iznik, known as the 'Golden Horn' style, of which again it must be admitted that it is a fairly banal example. Far finer specimens exemplify the style at its peak, though which of the two production centres was responsible for the better-quality ware is debatable. It should be noted that fragments so far excavated at

26 OPPOSITE Iznik blue-and-turquoise flask, painted in spiral style, c.1530.
HT 43 cm.

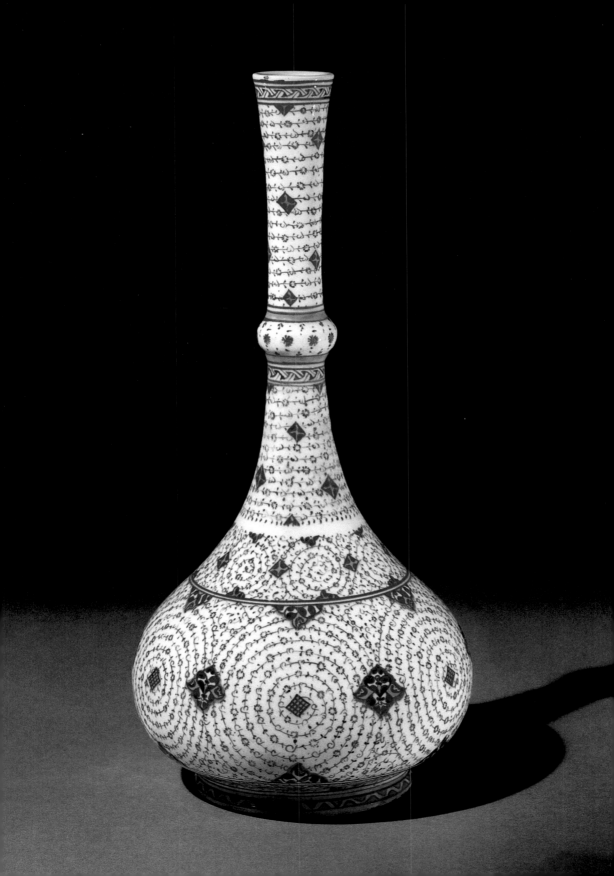

Iznik are equally humble, compared with the splendid pieces which survive intact in various collections throughout the world.

The name 'Golden Horn' derives from the fact that a quantity of broken examples and sherds of this type were dug up at Sirkeci on the south shore of the Golden Horn at the beginning of the century, when foundations were being excavated for the new Post Office (1905–9). An almost complete bowl is now in the Victoria and Albert Museum, and numerous pieces from among the large group of sherds acquired from that area in the 1920s are now in the reserve collection of the Benaki Museum in Athens, as yet unpublished. Although the ware was obviously not made there, the name has stuck, and like so many misnomers (of which 'Rhodian' is the classic example, for Iznik pottery with underglaze red) it is difficult to dislodge. What is not in doubt is its splendour, at its best; an excellent example is the flask in the British Museum, which humiliates the Godman flask by comparison. It has been suggested that this elegant object is based on a glass prototype, perhaps Venetian, and there is a further Italian connection with this spiral style, for similarly decorated dishes are based on the Italian *tondino*, and the leafy spirals themselves turn up in somewhat attenuated form on sixteenth-century Italian maiolica.

26

83

The body of the flask is decorated with five great coils of spiralling leaves, looking not unlike barbed wire. They are linked by rather curious lozenge-shaped clasps, with smaller cross-hatched diamonds at the centre of each spiral. The shoulder is decorated with a smaller version of the same design, and on the neck the spiral unravels, climbing slowly upwards to the rim, which bears a ring of knotted chevrons. It is generally acknowledged that the spiral decoration is a straight lift from manuscript illumination, where it is frequently used as a backdrop for the *tuğras* which adorn official *firmans*, documents issued under the sultan's monogram. The little rosettes are also found there, as well as ornaments in book design; so are arabesque medallions, which form a common border element.

Other vessels decorated in the spiral style include dishes, tankards, tiles and great basins on pedestal feet. Besides cobalt blue, some are painted with olive-green outlines, and there are often touches of turquoise, looking forward to the next polychrome phase of Iznik in which it breaks with the earlier monochrome blue-and-white style. The design of the dishes, often with foliate rims, shows some consistent features. The centre is painted with four or five spirals around a roundel; the cavetto is plain, except for a narrow garland, and the rim is decorated with a

vigorously undulating design. At some removes, all these elements can be traced back to early fifteenth-century Chinese blue-and-white, the spirals substituting for the flowers. The rim designs pick up the rhythms of the Chinese breaking-wave patterns, and they also have the nervous intensity of much of the porcelain of this period. Familiarity with Chinese ware is borne out by a shallow bowl in Berlin, which has a pair of concentric blue rings on the base in Chinese fashion, with a floral spray within instead of a reign-mark. A pair of candlesticks – based on bronze prototypes made for the Italian market – combine rosettes with spiral-centred flowers and tadpole-like leaves of the period. So does an odd hanging-lamp in the form of a fish in the Benaki Museum in Athens. Apart from the 1529 date of the Kütahya flask, tiles in the tomb of Mustafa Pasha at Gebze, east of Istanbul, also include little rosettes and hooked leaves in their designs; Mustafa Pasha died in 1528/9.

The reign of Sultan Süleyman (1520–66) heralds the expansion of the Iznik industry – and indeed the massive patronage of all the arts and the growth of a self-assurance which, while allowing the artist-craftsmen to draw on a wide variety of sources for inspiration, still manifests their confident originality. This rings out loud and clear in a series of dishes and other vessels in blue and turquoise, which like the tiles made at Edirne a century previ-

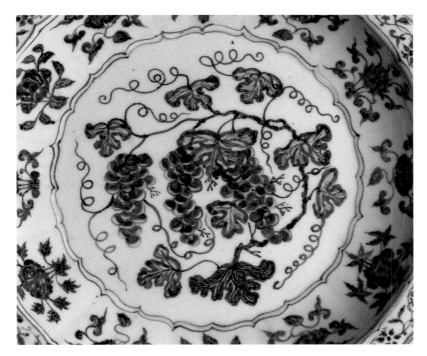

27 Detail of a Chinese blue-and-white dish, painted with bunches of grapes. 1403–24. DIAM 41 cm.

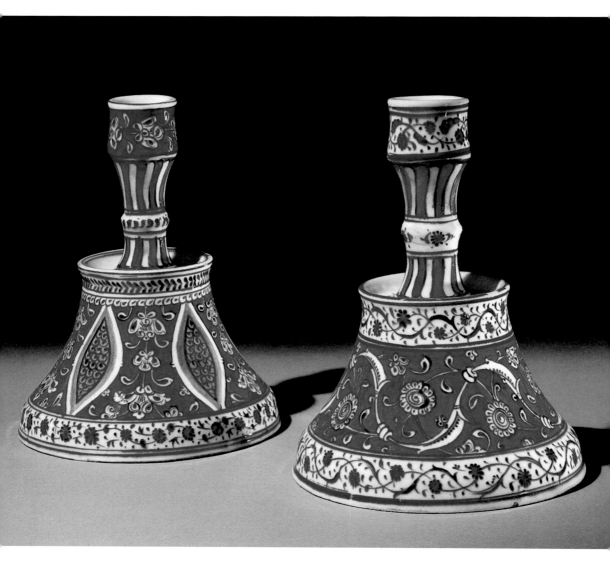

28 Two Iznik candlesticks, c.1530, painted in blue-and-white with tadpole-like leaves and spiral-style decoration. The shapes are based on Islamic metal forms of a type made for the Italian market. HT 43 cm.

ously, draw on both fourteenth- and fifteenth-century Chinese blue-and-white for their origin. Some, like the Iznik dishes with three bunches of grapes as their central motif, are re-interpretations of the Chinese blue-and-white (and celadon) design which are so vigorously painted that they transcend the originals. This seems to have been a popular design, for it is executed in varying degrees of sophistication. A dish in the Benaki Museum in Athens is an excellent example of one of the Iznik variants. Although the three bunches of grapes at the centre with their scalloped leaves, knotted vine-stems and prehensile tendrils fairly faithfully reproduce the Chinese prototypes, the floral sprays in the cavetto are

27

reduced to two distinct types, both much more stylised and singular than the sensitively drawn bouquets of different Chinese flowers. The breaking-wave design on the rim is an even more remarkable transformation, for while the Chinese fifteenth-century patterns are already stylised versions of the fourteenth-century Yuan motif, the Iznik potters have taken it a stage further. On the Benaki dish, the breaking wave has become an almost baroque panel, reserved against a ground of overlapping scales which have no connection with the surging sea. Later in the century the scale motif is transformed into a series of meaningless scrolls.

At the same time, in this group of blue-and-turquoise Iznik

29 Iznik blue-and-turquoise dish, *c.*1530–40, loosely decorated with a vase and floral motifs including simplified tulips. DIAM 34.8 cm.

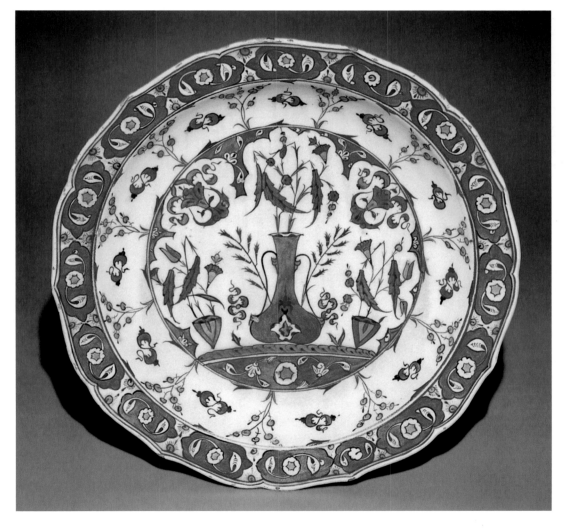

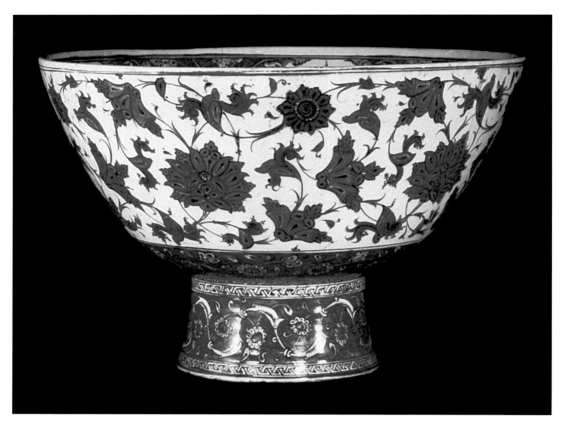

30 Iznik blue-and-turquoise deep bowl on a pedestal foot, c.1525. HT 28.4 cm.
ABOVE The exterior is decorated with various designs of stemmed flowers.
OPPOSITE Detail of the decoration at the centre of the bowl.

ware of the second quarter of the sixteenth century, the natural 29, world begins to assert itself. Tulips, hyacinth and carnations sit happily alongside cloud-scrolls and tadpole-like leaves. From the real world, motifs such as sailing ships, snakes, lions, trees and even a lugubrious young man in profile with a feather in his cap make an appearance. The simple naturalistic flowers are often arranged in vases, tankards or tall flasks, and most of the designs are now constructed on a vertical axis, floral sprays often springing from a leafy tuft. The idea of orientating a dish in such a manner is again a Chinese concept, nowhere more evident than in the giant early fifteenth-century landscape dishes in the Topkapı Saray collection.

Perhaps the most splendid of all vessels in the blue-and-turquoise group is the deep bowl on a pedestal foot in the British 30 Museum. The exterior is decorated with a fantastic wreath of flowers on vigorously curving narrow stems, with lobed leaves from which spiral seaweed-like growths. Below, there are interlocking stems bearing tadpole-like leaves and simple flowers with spiral centres, reserved on a blue ground. But it is the interior of the bowl which shows the painter at his most imaginative. At the

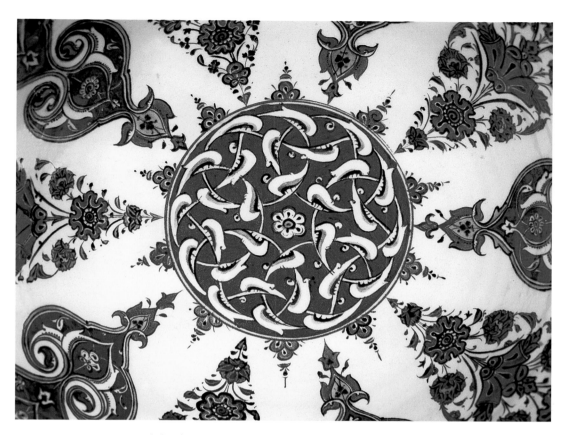

centre is a neat roundel of intersecting arabesques drawn from the repertoire of Balkan silver motifs. From this radiate five pointed medallions, symmetrical stems of palmettes, flowers and delicately painted leafy sprays. Opposing these open medallions are five tightly designed cloud-collar panels sweeping down from the rim, with the flowers reserved on a blue ground. This remarkable and unique design of subtly contrasting elements is further enhanced with touches of brilliant turquoise.

The vertical orientation of many of the dishes leads one to consider to what extent Iznik was meant simply to be displayed, as well as serving a utilitarian function as tableware. That it was for use and not simply decorative can be observed in the deep scratches and scuff marks on the working surface. But this writer has examined hundreds of Iznik dishes, and with rare exceptions they almost always have one or more holes drilled in the footring for suspension. The frequency with which these holes appear surely cannot just be attributed to later collectors, nor to a desire to keep the objects out of the way when not in use by hanging them on the kitchen wall. This remains an enigma.

4

IZNIK EVOLVES

Among the most startling examples of Ottoman tilework are five panels which decorate the façade of the Sünnet Odası (Circumcision Chamber) in the fourth courtyard of Topkapı Saray. There are two pairs of panels, with designs 31 mirroring each other, and a fifth slightly smaller panel by a unique composition. Painted in shades of underglaze blue and turquoise, four of the tiles have a complex design of gigantic flowers, swirling feathery leaves and pheasants, with pairs of animals, one snarling at the other, below; the whole design is framed by a scalloped arch with cloud-scrolls in the spandrels. The fifth, slightly smaller, panel depicts a vase of flowers. The panels are of extraordinary technical virtuosity, being over a metre ($3\frac{1}{2}$ ft) high, and painted with great skill and precision on a flawless white ground. Quite apart from the mastery of their style, to have successfully fired panels of such size is a unique achievement in the history of world ceramics.

Who could have executed them, let alone conceived their sophisticated composition? All the evidence points to the hand of Şahkulu, the leading court designer of the early sixteenth century. He himself was brought to Istanbul from Tabriz in 1514, one of the artists and craftsmen removed by Selim 1 during his conquests, and he became head of the *nakkaşhane* (court atelier) from 1526 to 1556. We know from many surviving drawings that Şahkulu was a master of the current style for arabesque designs incorporating saw-like *saz* leaves and writhing dragons. As painting on ceramics leaves no scope for correction, the artist can only have been someone sure of hand and confident of manner, far from the realm of a humble potter. Would such a master designer have gone to Iznik to carry out the work? Until recently these panels have been claimed as Iznik products, but Professor Gülru Necipoğlu has discovered evidence for pottery actually manufactured in Istanbul itself in the first quarter of the sixteenth century. These kilns were at Tekfursaray, up the Golden Horn at

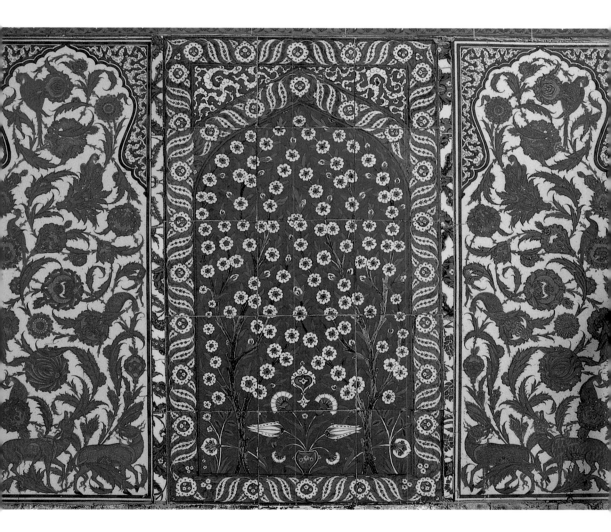

31 Two blue-and-turquoise tile panels, *c.*1527–8, flanking an Iznik polychrome tile panel, *c.*1560, on the façade of the Sünnet Odası in the Topkapı Saray, Istanbul. ʜᴛ 125 cm.

57

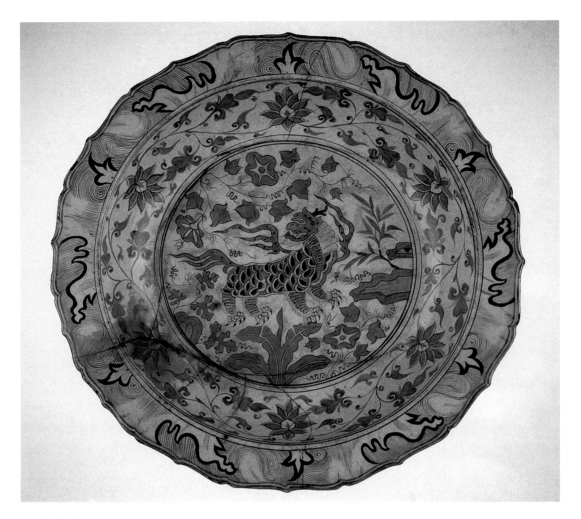

32 Iznik blue-and-white dish, *c.*1520, perhaps the most faithful copy of any Chinese porcelain dish of the Yuan dynasty. DIAM 40.2 cm.

the other end of the city from Topkapı Saray. The relevant archives consist of Sultan Süleyman's account books for 1527–8 during the extensive renovation of the palace. They list tiles specially made by the chief potter, Usta 'Ali, assisted by the court painters. The royal ceramic workshop (*kaşihane*) was itself founded by Habib, a potter brought from Tabriz like Şahkulu in 1514.

To return to the Sünnet Odası tiles, a close examination of the façade and the entrance doorway, with its stone frame inlaid with scalloped blue-and-turquoise tiles, and the surrounding panels of hexagonal and delicately painted border tiles makes it clear that they were all part of a carefully planned design. They were re-arranged at a later date to include later Iznik tiles, probably when the structure was enlarged to the south by Ibrahim I in 1641/2.

34

But enough of the early sixteenth-century tilework remains, which was also used in the revetments of the adjacent Privy Chamber, to grasp what the original scheme must have been.

This exceptional group of tiles is important, for there is a direct link to Iznik in the design of what must have been contemporary wares. There is a blue-and-turquoise dish in Vienna with a central design of a sinuous bird among feathery, swirling arabesque *saz* leaves and flowers which is directly related to these panels; the dish is of further interest, as it comes closest to imitating the diversity of floral and fruit sprays found on early fifteenth-century blue-and-white porcelain. And the real novelty is the inclusion of simple Turkish tulips on a single stem, perhaps the first time that this motif is used on pottery.

There are two more dishes belonging to this early group, dated about 1515–30, which should be considered in this context. One is a large dish in Berlin with a foliate rim, which is a straight lift from a Yuan prototype, with serpentine breaking waves on the rim, a lotus wreath in the cavetto with spiked, lobed leaves, and at the centre a lion in a landscape, which however stylised clearly shows the inspiration of a fourteenth-century Chinese master, whose style is identifiable from the loosely painted bamboo spray, plantain and stems of gourds and convolvulus with wiry tendrils. The second dish, in The Metropolitan Museum of Art in New York, stems from another source, Chinese celadon. As John Pope was the first to point out, this splendid blue-and-turquoise dish has a deep cavetto painted with a lotus-wreath of almost

32

33

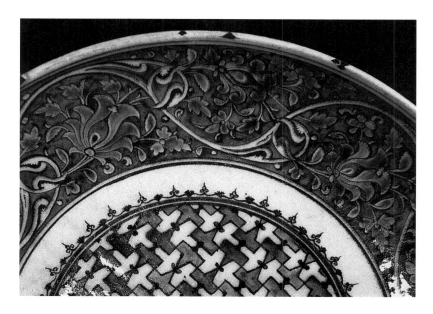

33 Detail of Iznik blue-and-turquoise dish, *c.*1530, imitating in its painting a 14th-century Chinese carved celadon prototype.
DIAM 39.4 cm.

34 Panel of under-
glaze blue-and-
turquoise tiles with
related border tiles,
*c.*1527–8, from the
Sünnet Odası in the
Topkapı Saray,
Istanbul.

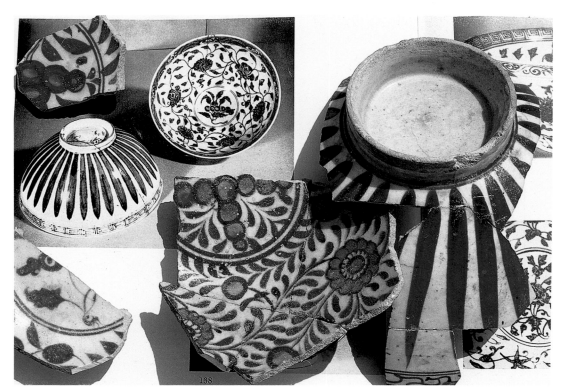

12

35 Four Iznik sherds with designs imitating Chinese blue-and-white *lianzi* bowls, *c.*1530, with photographs of the Chinese prototypes at upper left and at right. Excavated from the site of the new Post Office at Sirkeci, Istanbul, early in the 20th century.

three-dimensional character, closely echoing the carved details of a celadon original, as does the centre with its stylised diaper design. Finally, there is a further link to Chinese wares in a series of small blue-and-turquoise Iznik bowls, which follow the form and pattern of early fifteenth-century Chinese *lianzi* bowls. The radiating spear-like solid blue leaves on the outside, faithfully copied by the Iznik potters, are themselves a painted equivalent of the carved lotus-panels on celadon of the Song dynasty (AD 960–1279), an example of which is amongst the earliest celadons in Topkapı Saray. The interiors of the Iznik bowls are rather more original, for while some pick up and stylise the Chinese loquat motif, most are freely painted with chrysanthemums and swirling leaves, or strange coral-like motifs. In the same vein of celadon imitation is a jar with bands of leaf-like blue petals which also has its origin in the moulded ribs of Yuan ware.

The Sünnet Odası tiles and the Iznik dishes and bowls, as well as the spiralling wares of the 1520s, all indicate a close connection between the potters (whether in Iznik or Istanbul), the prevalent style of the court designers and artists, and a familiarity with the royal collection of Chinese porcelain in Topkapı Saray. Iznik is not exactly on the doorstep of Istanbul, being at least a couple

of days' journey away from the capital across the Sea of Marmara. How this transmission of the court style took place we have absolutely no idea; either the potters visited the palace to seek inspiration, or the *nakkaşhane*, the school of court designers, supplied Iznik with ideas, perhaps in the form of pounced cartoons. Arguing against this is the evident fact that during the second quarter of the sixteenth century, Iznik dishes and other forms are decorated three-dimensionally with a complete mastery and originality which could not possibly be based on flat paper patterns.

36 Iznik blue-and-turquoise jar, *c.*1530, loosely imitating a Chinese celadon jar (*guan*) with moulded ribs. HT 14.5 cm.

This sudden leap forward in artistic achievement was accompanied by an expansion of the palette used, to include (besides blue and turquoise) manganese purple, pale grey and a subtle and distinctive olive green. The designs are exuberant and imaginative, based on intersecting arabesques, *saz* leaves and flowers which may once have been lotuses and peonies but are now transformed into hybrids unknown to nature. There are also curious artichoke-like globes on thick stems, elegant tulips with slender curling petals, and more naturalistic sprays of hyacinth, pomegranates and pale pink roses. On the dishes, many of the bouquets spring from a leafy tuft, providing a vertical orientation for the design. On others there is a centralised design, perhaps with a rosette or arabesque surrounded by other similar motifs, stemming at many removes from the early fifteenth-century Chinese dishes with a similar format. Most conspicuous is the frequent use of a ground of overlapping scales; this motif has two possible sources, either the scaly dragons on Chinese blue-and-white or, more likely, the frequent use of such patterns on Chinese celadon. This would seem to be confirmed by a dish in the Musée de la Renaissance at Ecouen, near Paris, which has a rosette at the centre, in design exactly like those used to plug Yuan bowls. The four surrounding motifs, however, have all mutated into pomegranates. All these Iznik wares have a splendid sense of design and control, and yet through their rich and subtle colouring a certain restraint and sobriety, which accords well with what we know of Sultan Süleyman himself, during the latter part of whose reign most of them were conceived.

Luckily we have two fixed points which allow us to date this

37

43

41

37 Iznik dish, *c.*1550, painted with pomegranates, tulips and fantastic flowers springing from a leafy tuft. DIAM 37.2 cm.

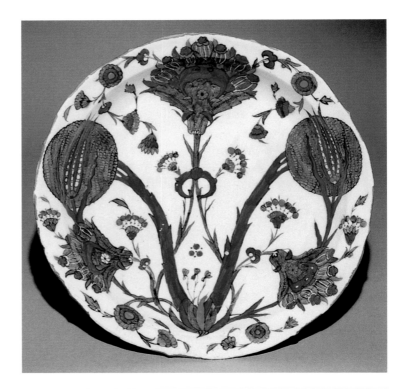

38 Iznik dish, *c.*1550, painted with a design of swirling arabesque flowers in the *saz* style, the epitome of the new style of the mid-16th century. DIAM 39.4 cm.

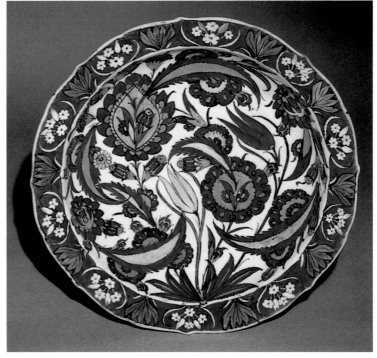

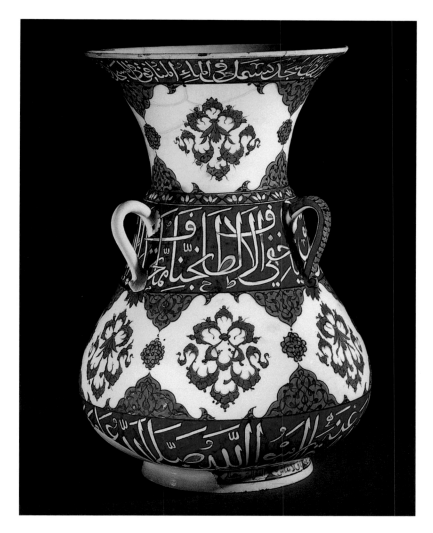

39 Iznik hanging-lamp, inscribed on the foot with the name of the decorator, Musli, and dedicated to the Iznik saint Eşrefzade, with the date AH 956/AD 1549. Found in Jerusalem in the mid-19th century. HT 38.5 cm.

40 Detail of the Iznik hanging-lamp (fig. 39) above, showing the three bands of Qur'anic and *hadith* inscriptions and the dedicatory inscription on the foot.

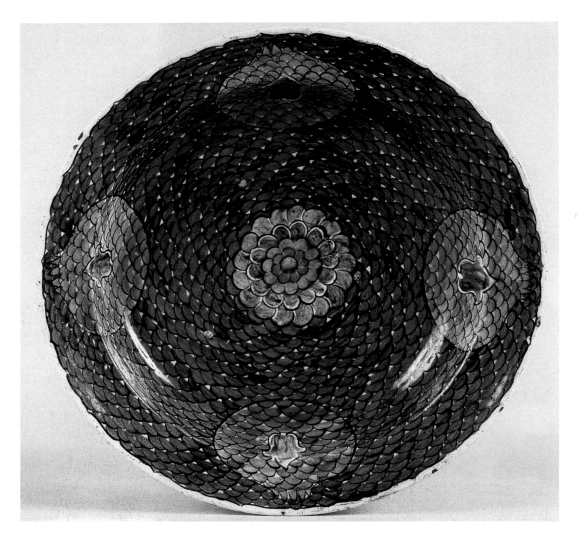

41 Iznik dish, *c*.1550, with a ground of overlapping scales on which are superimposed four pomegranates and a central rosette inspired by a Chinese celadon bowl. DIAM 30 cm.

distinguished group of wares with some precision. The first is a hanging-lamp in the British Museum, a supreme example of this style. Apart from three bands of Qur'anic inscriptions, the damaged foot bears a series of inscribed cartouches, of which six survive intact. These give the name of the decorator, Musli, and a dedication to the local Iznik Sufi saint, Eşrefzade Rumi; most important is the date, the equivalent of AD 1549: 39 40

[...] ol / derya yiye kim Iznik'te / Eşrefzade'dir. / Fi sene 956, / fi şehri Cemaziyel- / ula. Nakkaş / el-fakir el-hakir Musli /

. . . let that ocean [of esoteric knowledge] who is Eşrefzade in Iznik enjoy [any spiritual benefit]. In the year 956, in the month

of Jumada'l-Ula. The painter [responsible is] the poor and humble Musli.

The lamp was found on the Haram in Jerusalem in the mid-nineteenth century. It must have been associated with the refurbishment of the Dome of the Rock, initiated by Sultan Süleyman in the mid-sixteenth century, when in his role as Caliph he undertook the restoration of the Holy Places, including Mecca and Medina as well as Jerusalem. Befitting both its patron and its destination, the lamp is austerely but elegantly painted with formal bands of cloud-scrolls and arabesques and carefully executed inscriptions. The only light touches are a narrow ring of triple tulips on the neck, and the more informally written cursive inscription on the foot.

42 Directly associated with the lamp is a large

42 Iznik hanging ornament, c.1549, associated with the dated Iznik hanging-lamp of 1549 (fig. 39). DIAM 27.5 cm. ABOVE The top shows traces of kiln-spurs and distortion from the firing.

43 Iznik dish, c.1550, in the style of the painter Musli, with an olive-green arabesque on the turquoise ground of the central flower. DIAM 39 cm.

hanging ornament, now in the Benaki Museum in Athens and once meant to have been suspended above the lamp in Jerusalem. Such hanging ornaments are commonly found in both mosques and Orthodox churches throughout the Near East, and their origin, as suggested by the egg-like form, is to be found in the cult of fertility. The designs echo the interlacing arabesques on the lamp, both very close in style to metalwork of the period. Additionally there are large and small rosettes, and cloud-scrolls, and also the use of manganese purple and a pale greenish-grey. The top third is plain, indicating it was only meant to be seen from below. A further link to the lamp is a narrow band of more realistic flowers, this time groups of three daisies in cartouches, with rosettes between. The painter Musli was a master, and various motifs link these pieces to other Iznik dishes, bowls and a tankard, which if 43, not by Musli himself are certainly from the same workshop. Two of Musli's 'signature' motifs are olive-green arabesques or cloud-scrolls on turquoise, and tulips with three sweeping pointed petals, found on the three great pedestal bowls in the British 45 Museum.

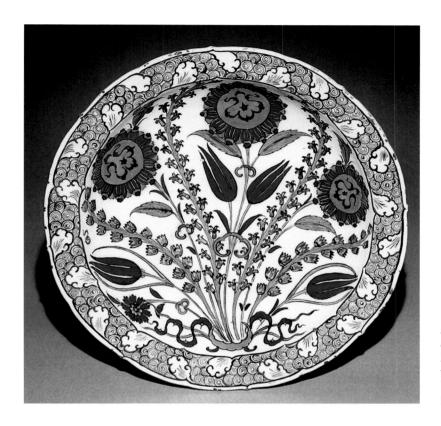

44 Iznik dish, *c.*1550, in the style of Musli, with a novel treatment of the breaking-wave border. DIAM 37.4 cm.

45 Detail of the centre of an Iznik bowl with a pedestal foot, *c.*1550, in the style of Musli. HT 23.7 cm.

46 Iznik tile panel, 1551, decorated in cobalt blue, turquoise, pale manganese purple and olive green. This is one of four inscribed lunette panels and two calligraphic roundels in the Ibrahim Pasha mosque at Silivrikapı in Istanbul.

Also close in style is a series of tiles in the Ibrahim Pasha mosque at Silivrikapı, just inside the ancient walls of Istanbul. This mosque, designed by Sinan, the greatest of all Ottoman architects, is dated AD 1551, just a couple of years later than the British Museum lamp. Under the portico are three lunette panels, with a pair of tile roundels above, and inside the mosque is a fourth panel. Like the lamp, the tiles are elegantly inscribed in white letters reserved on a dark blue ground, and some of the forms are filled in with turquoise. There are also delicately drawn tulips, carnations and other flowers in pale purple and turquoise, scattered throughout the text. Two of the panels have narrow turquoise borders painted in dark olive green with a running leaf design; the third has a repeating pattern of tiny rosettes. And at the apex of one panel is a symmetrical knotted device, quite similar to one on the central inscribed band of the Museum lamp. The two roundels are dynamically designed with interlocking letters to form geometric patterns. The panel inside the mosque is quite different, with a large cartouche inscribed in dark olive green on a turquoise ground, floating on a Weld of carefully inscribed interlocking arabesques. The Ibrahim Pasha tiles are, if anything, even more refined in design and execution than the Museum lamp. Apart from the motifs already mentioned, there is the unusual use of dark olive-green ornament on a turquoise ground, and this alone suggests that the tiles could hardly have been the

46

work of anyone other than Musli. It is not surprising that, if Musli was considered the best craftsman to carry out the commission for the hanging-lamp which formed part of Sultan Süleyman's restoration of the Dome of the Rock, Sinan would also use this master artist to supply the carefully integrated tiles for his mosque.

48 There is yet another group of tiles of this period, which decorate the interior of the Yeni Kaplıca *hammam* (baths) in Bursa. The baths are of ancient foundation, fed by the natural hot springs in the town. The tiles cover the walls and the arched recesses around the central pool, which is fed with opalescent warm water from a marble spout opposite the entrance. The tiles

47 are mostly hexagonal, of nine different designs, with tulips, arabesques and stencil-like radial designs, two of them painted with asymmetrical branches of prunus blossom. There are also rectangular border tiles with triple cloud-collar panels, and triangular tiles specifically made as fillers between the points of the hexagonal tiles at the top and bottom of each panel. The colours are in the now familiar combination of blue, turquoise, olive green and purple. There are several hundred tiles, sadly much dilapidated as a result of exposure to the warm sulphurous atmosphere. There are three tile inscriptions, of which the two above the marble spout are now so decayed as to be virtually illegible.

47 Eight of the designs on hexagonal tiles in the Yeni Kaplıca *hammam*, dating from before 1552–3, in Bursa.

The third inscription is painted in blue and turquoise on a single large tile, above the outer entrance to the bath. It is evidently a dedication to Rüstem Pasha, Sultan Süleyman's Grand Vizier and son-in-law, and it reads:

bina-i Rüstem dārā

the building of Rustem the prince

It can also be read as a chronogram; the *abjad* date is calculated by adding up the numerical values of each letter, which gives AH 960, that is, AD 1552/3. But this is misleading, for while it gives a date for the dedication and presumably the restoration of the Yeni Kaplıca baths, it cannot be applied to the hexagonal tiles.

These were removed from an older structure in Bursa, the Timurtaş *hammam*, which had dried up; Rüstem Pasha's building supervisor removed the tiles and marble basins from the defunct bath and reinstalled them in the Yeni Kaplıca. To this day, the impressions of the missing tiles can still be seen on the plastered walls of the Timurtaş *hammam*. There are even a few fragments of the tiles clinging to the edges of the walls.

What is significant about all these tiles of the second quarter of the sixteenth century is their testimony to the emergence of tile-work as a major Iznik industry during the closing years of Sultan Süleyman's reign. Until the mid-sixteenth century, Iznik had been mainly concerned with the production of pottery vessels. Although there was an independent band of Persian potters continuing to work in Istanbul in the *cuerda seca* tradition, they had been exclusively employed for the decoration of a number of royal monuments. These included the mosque and complex of Selim I, commissioned by Süleyman; the *imaret* dedicated to his wife, Hasseki Hürrem (AD 1539); and the tomb of his ill-fated favourite son Şehzade Mehmed (AD 1548). It was almost certainly this same group of Persian potters who were designated to carry out the restoration of the Dome of the Rock during the mid-sixteenth century. In Jerusalem, the Persian potters advanced from the older techniques of tile mosaic and *cuerda seca* to develop true underglaze decoration. This major project, which they successfully carried through to its conclusion in AD 1556, may have had a direct influence on the development of the Iznik industry, as a source of tiles nearer to home. If Jerusalem was indeed the stimulus, the Ottoman court was swift to realise Iznik's potential in the years to come.

48 OPPOSITE The interior of the Yeni Kaplıca *hammam* in Bursa, seen from the *soğukluk*. Above the entrance to the main bath or *harara* is the blue-and-turquoise tile inscription, dated AH 960/AD 1552–3 and dedicated to Rüstem Pasha. The central pool is filled from a marble spout at the base of the tiled wall at the far end.

5

THE PEAK OF
PERFECTION

The expansion of the tile-making activities at Iznik was accompanied by a significant change of style. This may well have been due to the intervention of court designers and architects who would dictate the parameters within which the Iznik craftsmen had to work. The architect Sinan was certainly conscious of the role the tilemakers could play in embellishing the façades and interiors of his buildings. In all of his work, with one notable exception, the use of Iznik tiles was always subordinate to the grand design, and carefully structured – for instance, the tile panels under the portico of the Süleymaniye mosque (1550–57) – to accent certain areas and no more. Sinan's style relies for effect on a certain sobriety, and his genius is the manipulation of basic elements of line and form in imaginative and hardly ever repeated combinations. Each building is like a fresh start, each one a testimony to his ever-evolving ingenuity.

The exception is the mosque of Rüstem Pasha, who served as Grand Vizier to Sultan Süleyman from 1544 to 1553 and again from 1555 until his death in 1561. Rüstem Pasha's role in charge of the Ottoman revenue was fundamental, and he further consolidated his position by the time-honoured expedient of marrying the boss's daughter, in this case the Princess Mihrimah. An unsavoury character, his reputation for meanness included stories that he abandoned his own father and family, and the traveller Busbecq relates an anecdote that he gathered the flowers and vegetables from the Sultan's garden so that he could sell them profitably in the market. However that may be, the mosque that bears his name is to this day a vivid component of the marketplace. It is in Tahtakale, a bustling quarter of artisans and small shopkeepers nestling on the shore of the Golden Horn, dominated by the Süleymaniye on the skyline above. For this reason, Sinan designed the mosque on a series of vaults (incidentally

49

housing the shops producing revenue to sustain the foundation) so that it rises above the street. Climbing by an internal staircase, the worshipper finds himself on a stone platform in front of the mosque, with an open arcade looking down on the bazaar, so that one is still aware of the world below, yet spiritually aloof from it.

Preceded by a double portico, there is an assortment of tile panels on the outer wall, but these do not prepare the visitor for the shock upon entering the mosque. The plan is simple enough, with a dome supported on eight arches and exedra to the north and south, but every inch of the walls up to the level of the top of the two galleries is covered with Iznik tiles. These are of such splendour and variety that they are hard to take in at first glance. They are, in fact, the equivalent of a tile museum, a perfect repertoire of every current Iznik design. It is known that the mosque was complete by 1559, and the tiles, which are such an integral part of the structure, must be of similar date. Apart from dozens of different designs, they also display a new palette. Replacing the dignified restraint of blue and turquoise, muted purple and olive green, the new style is executed in shades of cobalt blue, turquoise, viridian green and tomato red thickly impasted under the flawless transparent glaze. This red has been aptly compared to sealing-wax, which is exactly the effect it conveys.

But what makes the tiles in Rüstem Pasha particularly interesting is that not only do they herald the peak of Iznik, from the 1560s onwards to the end of the century, but they also contain the seeds of this new style. In many of the tiles the red is not fully developed and has a transparency, rather like a drop of blood splashing into a bathroom sink. At the same time, some of the tiles still use manganese purple and the earlier olive green. This is most noticeable on a large panel under the portico, just to the left of the main entrance. Here a brilliantly conceived and painted panel has a flowering prunus as its subject, and around it at the base are extraordinary sprays of tulips with spotted petals, hyacinth, carnations, roses and pomegranates, all mixed up with rococo rocky outcrops through which they twine and interpenetrate. A similar panel with a flowering tree decorates the outer wall of the tomb of the Sultan's wife Roxelane, in the royal cemetery which forms part of the Süleymaniye complex. Here the new red, cobalt blue and turquoise also include a sparing use of pale olive, and the tree trunk itself is a dark manganese purple. Roxelane, or Hasseki Hürrem as she was more properly known, died in 1558. When Sultan Süleyman's own nearby tomb was completed, shortly after his death in 1566, it was also tiled. But neither the olive green nor the manganese purple survive, and

50

49 The tiled interior of the Rüstem Pasha mosque, 1559, in the Tahtakale quarter of Istanbul, seen from the upper north gallery, with the *mihrab* and marble *minbar* on the left.

instead a virulent new green makes its debut. This effectively helps to pinpoint the introduction of the new colour range to about 1560.

What about the pottery vessels? Here it is also possible to trace the intermediary stages which mark the introduction of the new idiom. A key piece is a hanging-lamp, now in the Victoria and Albert Museum, which once graced the new Süleymaniye mosque and can therefore be dated before AD 1557. Of quite ugly design compared with the Dome of the Rock lamp of 1549 in the British Museum, it is also incoherently decorated, and the new red is unevenly applied, with the familiar transparency. Two hanging ornaments, one of which is in the Museum, are also decorated in a style related to the lamp. And there are a number of dishes which are also painted with transparent orange-red, some even with a supplementary greyish-green, a hangover from the past. One such is in The Metropolitan Museum of Art in New York, another is in Ecouen, and a third was in the Lagonikos

50 Detail of the large Iznik tile panel, *c.*1560, under the portico, just to the left of the main entrance to the Rüstem Pasha mosque in Istanbul. In addition to blue and turquoise, the tiles combine the new red with manganese purple for the stems of flowering prunus.

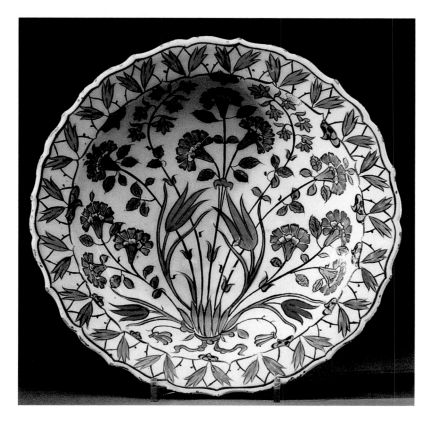

51 Iznik dish, *c.*1560, decorated in shades of cobalt blue and pale grey-green with the transparent orange-red of the transitional period. DIAM 30.2 cm.

collection from Alexandria. Even the designs are unusual, harking back to the fantasy of the 1550s; a common motif is a tulip with three long spiky petals.

The Rüstem Pasha tiles can be said to mark the inception of a major tile-making industry at Iznik. Exactly how this was organised we do not know, but it was certainly controlled from Istanbul. A number of documents exist, crossly urging the tilemakers to concentrate on their imperial obligations; the regular supply of tiles for the new mosques and palaces must take precedence over any other commissions. As in the case of Rüstem Pasha, it is evident that there had to be an extremely close relationship between the architects and the tile designers, for the finished product had to fit accurately into the building. Specially designed *mihrab* niches, tiled *minbars*, spandrels, inscribed panels, and tile roundels to decorate the pendentives below the dome – all had to be tailored with precision. To cite one technical problem alone, tiles meant for a specific location had to take into account the shrinkage of the clay during their manufacture, which had to be carefully calculated. It is also clear that any building designed by Sinan would require tiles which would conform to his strict instructions, not only of measurement but also of design. It has been conjectured that the *nakkaşhane* (court designers) played a leading role in supplying designs that the potters would then carry out, which would account for the general consistency of style amongst all the decorative arts in the sixteenth century, including ceramics. But it is much more likely that the real symbiosis was between the architect/engineer and the Iznik master craftsmen. It also follows that tiles manufactured for a specific location would often require the tilemakers themselves to visit the site, and there must have been a considerable to-and-fro between Iznik and the capital.

Further afield, nowhere is the controlling hand more evident than at Edirne, where Sinan's acknowledged masterpiece was the Selimiye mosque, built between AD 1569 and 1575. This noble building expresses a total mastery of space, the great dome, semi-domes and supporting arches pierced with shafts of light. The building is equally impressive outside, seen either from afar or close at hand, its positive sculptural forms set off by four towering pencil-slim minarets, almost like space rockets poised for take-off. Inside, the tile decoration is of superlative quality and design, playing a very specific part in the overall plan. The *mihrab* is of plain carved stone, but is flanked on either side by richly patterned tiles with central scalloped medallions, and broad bands of stately Qur'anic inscriptions above. The *minbar* or

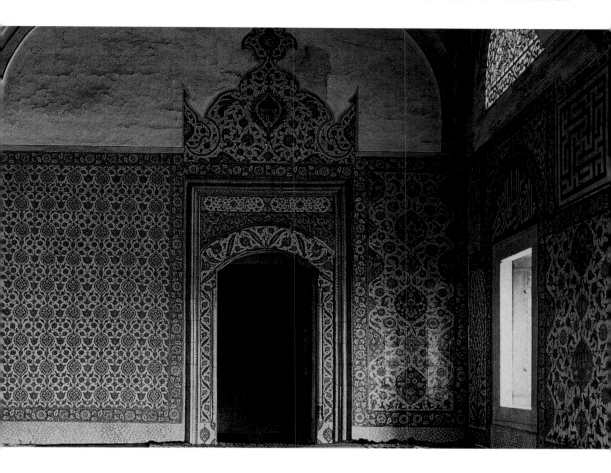

pulpit is of elegantly fretted marble, and surmounted by a tiled hood with rows of diminishing medallions sweeping the eye upwards to the golden finial and crescent *alem*. Elsewhere in the mosque the tiles are used as lunette panels and for further inscriptions. The most sumptuous of all are appropriately reserved for the sultan's loge. Here, sinuous floral panels contrast with fields of more formal arabesques, flanking the grand entrance. Curving *saz* leaves almost convey the idea of the sultan progressing through into this private space, the whole composition emphatically framed by a deep stone moulding. Above there is an impressive pediment, a cloud-collar panel filled with flowers, half-palmettes on either side and a palmette to crown the whole design. The central feathery medallion is like a stylised plume in the sultan's turban, and nothing could visually convey the idea of majesty better than this extraordinary tile frieze, perhaps the finest ever produced at Iznik.

If the creative genius of the designers and Iznik craftsmen was

52 Iznik tiles in the sultan's loge of the Selimiye mosque, 1569–75, in Edirne.

52

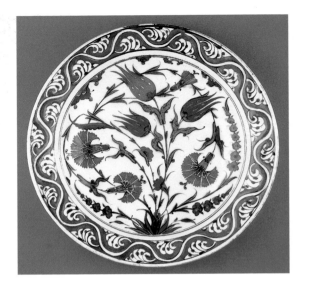

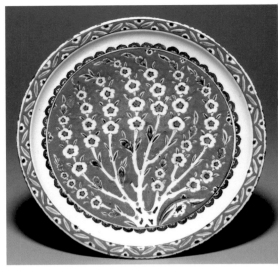

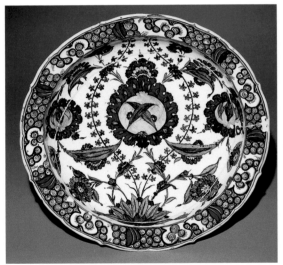

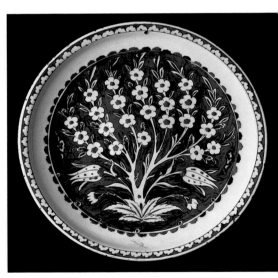

primarily channelled into tilework during the third quarter of the sixteenth century, it also had an impact on the more pedestrian production of dishes and other vessels, many using the same novel combination of vivid colours. At their best, the designs have a brilliance and self-confidence which suggest the artist-potters have broken free from the constraints of the court designers and are exploring their own inventiveness. At this stage in the evolution of Iznik scholarship one can hardly do more than note the general types of design and their evolution. Although excavations have been carried out at Iznik during recent years, it is still

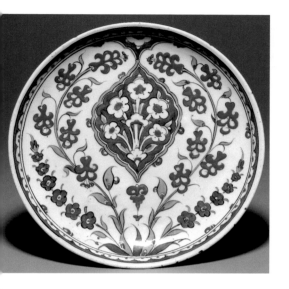

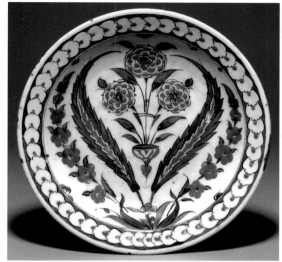

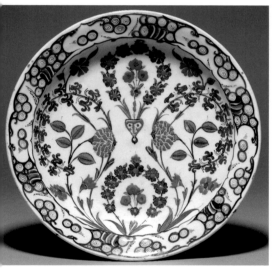

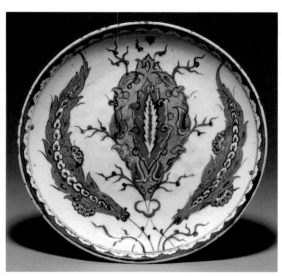

3–60 A selection of Iznik dishes.

OPPOSITE

53 ABOVE LEFT Dish 1570–1600. DIAM 30.6 cm.

54 ABOVE RIGHT Dish 1575–1600. DIAM 32 cm.

55 BELOW LEFT Dish, sixteenth century.
 DIAM 36.2 cm.

56 BELOW RIGHT Dish, c.1585. DIAM 33.7 cm.

THIS PAGE

57 TOP LEFT Dish, 1601–25. DIAM 28.5 cm.

58 TOP RIGHT Dish, 1601–25. DIAM 31.2 cm.

59 ABOVE LEFT Dish, sixteenth century.
 DIAM 31.5 cm.

60 ABOVE RIGHT Dish, sixteenth century.
 DIAM 31.8 cm.

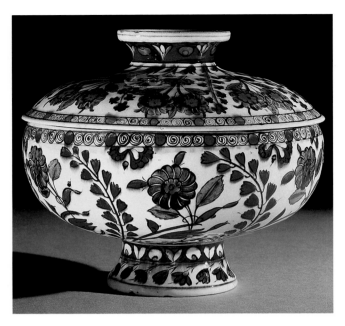

61 Iznik covered bowl with a lid, *c.*1550, the shape modelled on a gilt-copper (*tombak*) form and decorated in mid-16th-century style. HT 19.5 cm.

far too soon to have any clear idea of how and where the actual workshops were organised. Using the analogy of the present-day industry at Kütahya, so brilliantly documented by the American ethnologist Henry Glassie, it is probable that they were mostly family concerns, each producing a particular product. As their individual works were so seldom signed, the relationships between the different workshops and their individual craftsmen remain obscure. There was presumably some sort of guild structure; directives from Istanbul to give priority to particular projects were not addressed simply to thin air, but to the Kadi of Iznik.

Among the most popular and numerous designs are dishes painted with a central spray of tulips and other flowers and serrated leaves, springing from a leafy tuft on the lower margin of the cavetto. These can be traced back to the Chinese blue-and-white floral spray dishes of the early fifteenth century, where the spray is often tied with a loose ribbon. The Iznik dishes tend to be of more formal and symmetrical design, but this is not always so; a few are painted with striking asymmetrical designs. The wide sloping rim frequently has a foliated edge and is commonly painted with an adaptation of the Yuan breaking-wave border, abstracted to a greater or lesser degree. Indeed, it is possible to trace the decline of Iznik pottery into the seventeenth century through the gradual degeneration of this motif, until it finally becomes nothing more than a series of meaningless spirals. Other dishes are shallower and with a narrow rim; many of these are painted with prunus sprays, often on a brilliant red ground. The other major group is painted with centralised designs, often radiating from a single rosette. At many removes, these also hark back to the great series of Yuan blue-and-white dishes and celadons. Besides derivative lotus-panels and cloud-collar designs, there are also motifs of more Ottoman flavour such as rings of spiky palmettes. Other dishes have borders of spiralling, sharply curved petals, which look like flaming Catherine wheels. Yet more dishes have a central cypress tree flanked with sprays of

tulips and other flowers, among the most elegant and delicately painted of all the dishes of this period. Possibly the most surprising and unconventional are a set of dishes, of which ten have survived; these are painted with different combinations of leafy floral sprays, but each with a European coat-of-arms at the centre. Although there has been much speculation about whose arms these are, the only general conclusion is that the dishes were commissioned by an Italian or possibly Dalmatian client. Of the Iznik origin there is no doubt, for a fragmentary example was found in excavations there. The Italian connection is interesting, for Italian maiolica of the period shows the clear influence of 83 Turkish wares, such as an *albarello* with spiralling 'Golden Horn' 91 design, and polychrome maiolica dishes reflecting Iznik floral and leafy motifs.

If Iznik dishes themselves generate most of the designs, many of the forms derive from non-ceramic sources. Metal shapes are an obvious inspiration, as they have been for potters throughout 61 time. Covered bowls on a pedestal foot originally made of gilt copper, or *tombak*, are quite faithfully copied in pottery. So are

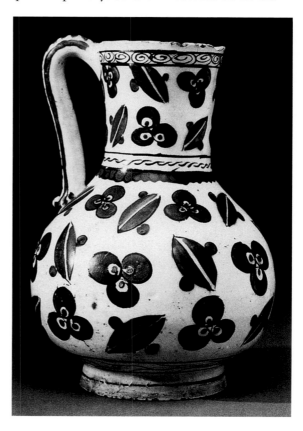

62 Iznik jug, *c.*1575, decorated in cobalt blue, viridian and relief red with black outlines. HT 21 cm.

Iznik candlesticks, which imitate the general design of metal prototypes, if not their decoration. There is even a bizarre Iznik ewer which copies a Serbian lead prototype, a mistake which engendered probably one of the ugliest pieces of Iznik in existence. 62 Single-handled Iznik jugs, often with a torus moulding at the junction of neck and body, must also be imitating metal forms. These are quite common and often charmingly decorated with simple motifs, sprays of flowers and *çintimani*, groups of three crescents, and spiralling panels perhaps copying repoussé prototypes. And a number of 63 Iznik tankards copy leather forms. These have angular handles, and although Arthur Lane suggested a wooden prototype (of which examples exist) it is more likely to have been of leather, for the actual stitching is often 63 replicated in the painting of the handle, and the foot is a recessed disc, as it would have been in that material. This

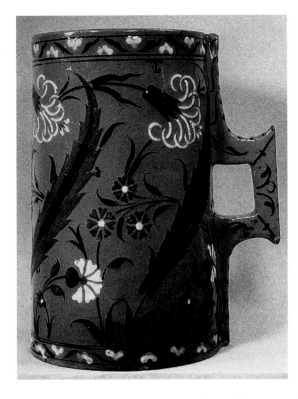

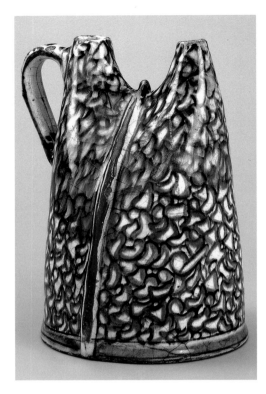

63 ABOVE LEFT Iznik slipware tankard, *c.*1560, decorated in black, red and white on a blue ground. HT 21.7 cm.

64 ABOVE RIGHT Iznik water-vessel *(matara)*, *c.*1575, in underglaze blue, green and red, copying a leather prototype. HT 17.8 cm.

is confirmed by a unique *matara*, or water-vessel, which also 64 copies a leather form, where the hind quarters of a quadruped are sewn up, one leg becoming the spout and the other the handle, to be used when inverted to drink from, in the same way as a *kendi*. The sultan's own *matara* was an even more aristocratic version, of bejewelled jade and gold, but with the same humble origin.

Finally, there are conical Iznik tankards which in form are based on silver-gilt tankards of Balkan origin. Balkan silver played a large part in the Ottoman empire, as noted earlier in the design of the first phase of Iznik monochrome wares. The taste for Balkan silver continued throughout the sixteenth century and, as noted above, wine bowls often had elaborate enamelled plaques riveted to the inside. A later style of Balkan silver, decorated with fantastic birds and animals, was also popular at the Ottoman court, and examples are known with the *tuğras* of Ahmed I (1603–17), Osman II (1618–22) and Murad IV (1623–40). These inspired a whole group of Iznik pottery in what might be christened the 'Mickey Mouse' style. The silver link is proven by an Iznik jug of truncated conical form, closely echoing a Balkan example and also imitating its animal decoration. This group often has an extraordinary menagerie depicted

on a green ground. On dishes of this type a common design depicts bewildered hunting dogs chasing after hares with grins all over their faces. Other examples include monkeys, phoenix, snakes and birds of all sizes, and even pairs of harpies. A common subsidiary motif is an oak-leaf, used as a filler design. The style is well represented in the British Museum by a deep 65 bowl, a flask and a *tondino* dish; whatever serious symbolism may originally have been intended, they are a testimony to some-one at Iznik having a sense of humour.

Another distinctive group of Iznik pottery can also probably be dated to the second half of the sixteenth century. This consists 67 of dishes, jugs, vases and tankards, all crisply painted in dark ultramarine blue with floral designs with distinctive feathery leaves. A number of pieces, the jugs and tankards, also have plain slip decoration under the glaze. The flowers, painted solid blue with outlined petals, have a curious mask-like appearance, and another characteristic is an undulating stem with cloud-like petals. The reverses are often painted with floral sprays quite unlike anything else from Iznik, derived from Chinese blue-and-white of the mid-sixteenth century. Many of the dishes have double concentric rings on the base, rather like Chinese reign-

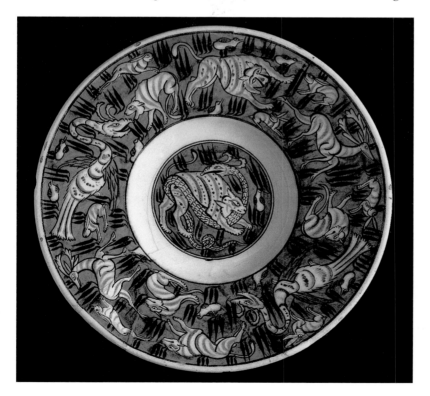

65 Iznik dish, *c.*1560–65, in the form of an Italian *tondino* with a wide rim and recessed centre, decorated in the animal style. DIAM 22 cm.

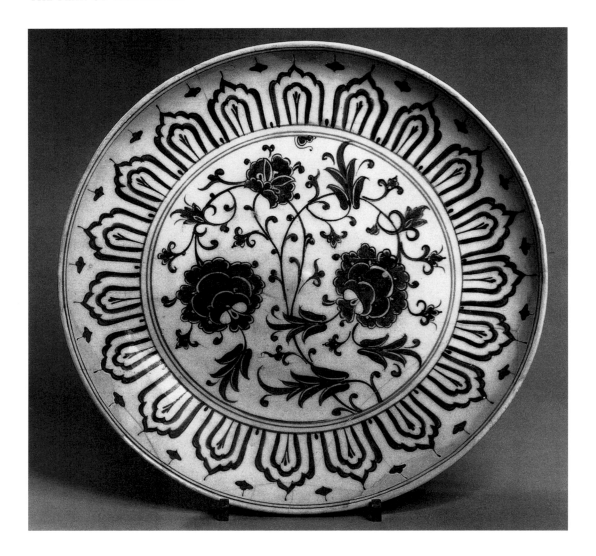

66 Iznik/Kütahya dish, *c.*1575. DIAM 35.5 cm.
ABOVE The dish is decorated in dark ultramarine blue
with mask-like flowers.
LEFT Base of the dish, with distinctive asymmetrical leafy
sprays, a single ring inside the foot and double concentric
rings at the centre.

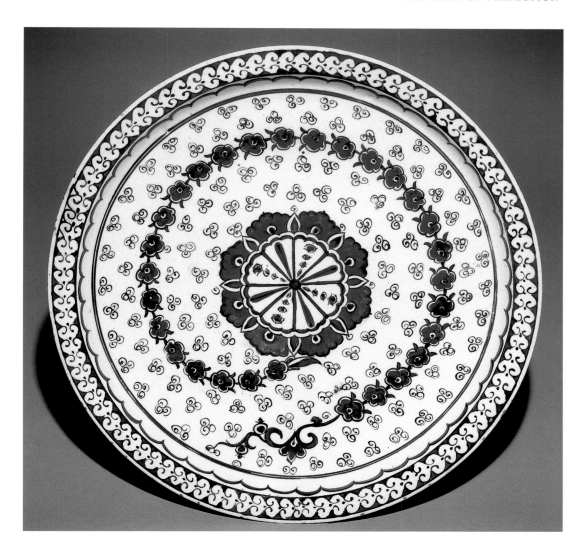

67 Iznik/Kütahya dish, c.1575, decorated in dark ultramarine blue. DIAM 33.5 cm.

marks but without the six Chinese characters. These would appear to have been copied from Chinese porcelain, and there are indeed many blue-and-white dishes in the Topkapı Saray collection which also bear the concentric rings without the characters. The continuing use of such double rings is a feature of eighteenth-century Kütahya pottery, and this and the unusually dark ultramarine blue (another Kütahya characteristic) led the writer to propose that this group may well have been made there rather than at Iznik. As Kütahya is mentioned in a number of literary sources as a pottery-manufacturing town in the sixteenth century, it stands to reason that some of the pottery ascribed to Iznik must in fact be from Kütahya, and this group seemed a

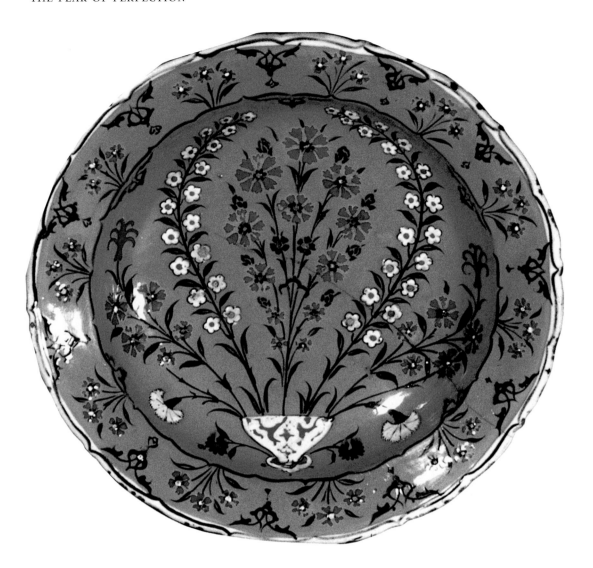

68 Iznik slipware dish, *c.*1560, decorated in black, white and red on a blue ground. DIAM 35 cm. Formerly in the collection of Lt-Col. R.H. Brocklebank.

likely candidate. But militating against this proposition is the evidence of (unpublished) sherds of this type, excavated at Iznik and now in the Nilüfer Hatun museum there. Attractive though it had seemed to ascribe the group to Kütahya, one must conclude that they are probably from Iznik, the work of a singularly distinctive atelier.

Slip decoration is used on yet another group of Iznik, the 68 dishes and jugs covered with an all-over pale blue, pale orange or coral red ground, decorated with white, red, black or blue opaque slip designs, often with loosely brushed greenish-black details. The designs are simplified versions of the familiar floral

patterns on underglaze-painted contemporary Iznik ware, but because of the unusual technique have a sort of spontaneous peasant-like gaiety. They are also reminiscent of a type of Chinese provincial ware decorated with white slip on a blue ground and generally ascribed to Swatow. But as the Swatow dishes are of seventeenth-century manufacture, there is the intriguing possibility that they themselves were inspired by the slightly earlier Turkish slipware. That the Turkish ware had a wide circulation we know from a number of sherds of plain and coloured Iznik slipware excavated at Salonika, all of very high quality. An earlier example of Iznik slipware is a dish in the Topkapı Saray museum, which has a central hexagonal design of plain white slip close in composition to the painted design on a dish in the British Museum, in blue, olive green and manganese purple. The same design occurs more appropriately on hexagonal blue-and-turquoise tiles and is also found among the patterns used in the Yeni Kaplıca baths in Bursa. What is particularly interesting is that this sixfold design radiating from a central rosette should persist, with variations, throughout the first half of the sixteenth century, but should in turn look backwards to similarly organised hexagonal designs on the tiles at Edirne, a century before.

6

IZNIK, CHINA AND THE WESTERN WORLD

A fundamental problem with the study of works of art outside one's own cultural tradition is the extent to which one can ever penetrate the psychology of the artists who created them. It is one thing to apply objective criteria of technique and style, treating objects as if they were some kind of geological phenomenon. But it is quite another to try to guess

69 Iznik dish, *c*.1580–85, decorated with *çintimani* and tiger-stripes. The overall pattern derives from a Chinese celadon design. DIAM 34.5 cm.

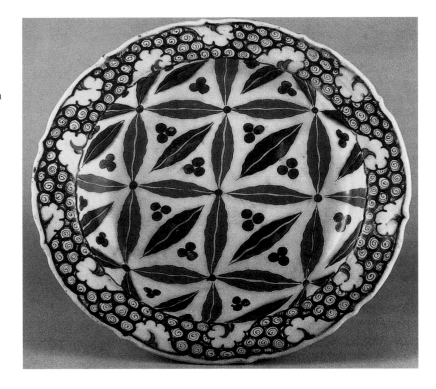

exactly the frame of mind and subjective motivation of the artist-craftsmen. In the case of Iznik, where we know little of the ethnic background of the potters and can only presume that the majority were practising Muslims, we have no clue as to why they should have chosen a specific set of motifs and combined them in a particular way.

We have already noted that the potters were sensitive to Chinese designs and individual motifs, drawn both from blue-and-white porcelain and celadon. This susceptibility does not mean that they understood them, and it is fairly obvious, for instance in the case of the serpentine waves-breaking-over-rocks design, that they did not. Nor did they really understand the Chinese flora, the peonies and lotuses being transformed into hybrid forms far removed from the natural world. As for cloud-scrolls, they were tidied up and turned into symmetrical arabesques. Apart from *chinoiserie*, even such traditional Turkic motifs as *çintimani* and tiger-stripes were transmuted into dynamic, decorative 69 symbols. On a dish in Lisbon, they are used to create an all-over diaper design, like nothing so much as an exaggerated interpretation of the carved diaper on a celadon dish. And 70 on a flask in the British Museum, the *çintimani* and scarlet stripes are used to impart a striking lattice around the 71 body of the vessel. On another dish, also in the Museum collection, the stripes disappear altogether and the *çintimani* are reduced to mere fillers, with blue petals, between six large scalloped flowers on a scaly ground; they have entirely lost any emblematic significance.

Another object in the British Museum with an unusual combina-72 tion of motifs is a noble hanging-lamp of traditional form, decorated in sober shades of grey-blue, with large discs filled with intersecting triangles forming six-pointed stars in the strict

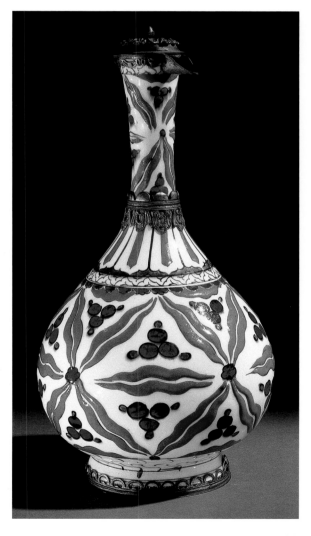

70 Iznik flask with gilt mounts, *c.*1580–85, with scarlet tiger-stripes and blue *çintimani* with viridian dots. HT 28.5 cm.

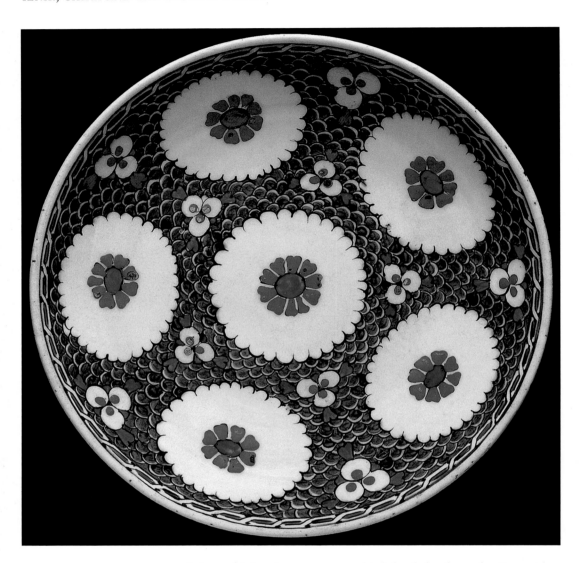

71 ABOVE Iznik dish, c.1580, with a scaly ground, with *çintimani* as fillers. DIAM 33 cm.

tradition of Islamic geometry, which hark back to the Bayezid II lamps of the early sixteenth century. In between are rosettes of overlapping shaded petals which can only derive from the moulded plugs at the centre of Yuan celadon bowls. The eclecticism is exemplified by the base of the lamp, which is decorated with a rosette in vivid cobalt blue with scarlet dots and green leaves, bearing no relationship whatsoever to the lamp's exterior. But for this rosette, one might have been tempted to date it a

72 Iznik hanging-lamp, c.1580. HT 44 cm.
OPPOSITE The decoration is a combination of geometric and floral motifs.
LEFT Detail of the polychrome rosette on the base of the lamp.

73 Iznik hanging-lamp, *c.*1575, decorated in blue, green and relief red with black outlines and Hebrew inscription (upside down). It was probably made for the Jewish community in Istanbul. HT 25.5 cm.

good deal earlier than the second half of the sixteenth century. To the same period belongs another smaller lamp, covered with intersecting panels of blue or green scales. This in itself would not be remarkable, but on the shoulder in cartouches between the three handles is a Hebrew inscription. This is written upside-down in characters suggesting the Iznik craftsman was no Hebrew scholar, and indeed its translation has posed problems. 73

מ׳ררה ⟩ ⟨ כו׳הש ⟩ ⟨ וחהת

It is transcribed: SAAYIDDAH/LOHASH/VEHAHAT, but has so far defied any convincing explanation. It would suggest that the potter worked uncomprehendingly from a model text. More interesting is the fact that this Hebrew-inscribed piece of Iznik is unique. One can only presume it was commissioned for the Jewish community in Istanbul. Since their emigration from Spain in 1492, they had risen to prominence in the Ottoman empire, and the Chief Rabbi had a status equal to the Greek Patriarch in Istanbul. At the time of the lamp's manufacture, c.1575, the leading member of the community was Don Joseph Nasi, who had consolidated his power by backing Selim against his brother Bayezid after the death of Sultan Süleyman in 1566. As a philanthropist, Don Nasi may well have commissioned the lamp for one of the synagogues he financed. Conversely, it could have been a court commission for presentation to the Jewish community. As has been written, for the Jews of the fifteenth and sixteenth centuries, the Ottoman empire was a most remarkable and salubrious home.

78 A tangential example of external influence, at two removes, are Iznik plates with roundels decorated with devices which at first glance appear to be inscrutable. In fact, they are interpretations of the designs on a group of Chinese blue-and-white porcelain of the first half of the sixteenth century, made for the Portuguese who had newly arrived on the Far Eastern horizon.

74 Chinese blue-and-white porcelain bowl, 1541. DIAM 25 cm. BELOW LEFT The bowl is painted with the arms and armillary sphere of Manuel I of Portugal (1461–1529), and inscribed with the name of Pero da [de] Faria, Captain of Malacca, and the date 1541. BELOW RIGHT Interior of the bowl.

75 BELOW The arms of Manuel I of Portugal. Woodcut from *Regimento do oficias das cidades, villas e lugares destes Reinos*, 1504.

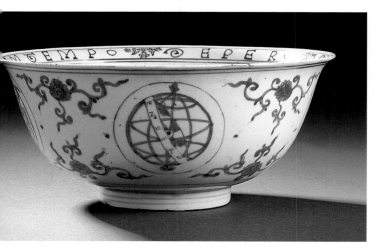

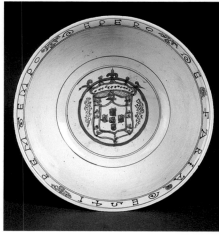

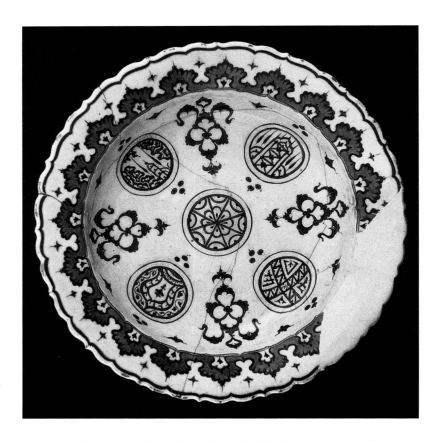

76 Iznik dish, *c.*1560, decorated in underglaze blue, with roundels deriving from the arms of Manuel I. DIAM 34.1 cm.

One bowl in particular, which is in the Topkapı Saray collection, is somewhat illiterately inscribed by the Chinese potter in Portuguese with the name of the Captain of Malacca, Pero da [de] Faria, and the date, AD 1541. It bears also the arms of the King of Portugal, Manuel I (1461–1529), a shield and an armillary sphere. But already the Chinese had made a few changes; the angels supporting the shield on either side have been replaced with what look like sea-horses, and the crown above breaks through the confining circular frame and becomes much more sympathetic in design to the adjacent Chinese scroll motifs. As for the armillary sphere, this retains the sash-like inscribed diagonal band, the other elements being simplified into pointed ovals.

But once the Iznik potters got their hands on the same elements, there are more radical changes. On one dish the shield loses its crown, and shape, and the angels/sea-horses are simplified into a running scroll. The armillary sphere is reduced not to one but two diagonal sash-like bands, with angular motifs between. And new motifs are introduced, such as an arched shrine flanked by cypresses, and a minaret with coral-like

74

75

76

outcrops on either side. Between the four roundels are symmetrical arabesque clasps, once cloud-scrolls, and *çintimani*, again reduced to mere triple spots. At the centre is a radial design with six compartments, the potter's attempt to rationalise the seemingly irrational prototypes. This roundel then turns up on a cover with a finial, actually excavated at Iznik, alongside the distorted armillary sphere and shrine with cypresses. More fascinatingly, it picks up the pairs of symmetrical scrolling motifs which separate

77

the roundels on the outside of the Topkapı bowl, and even the spacer dots, which it encircles.

This leads to a further question: did pieces of Chinese porcelain actually travel to Iznik, on loan from the Topkapı Saray, to inspire these adaptations? It is hard to see how the influence of the Portuguese/Chinese elements could have been transmitted otherwise. Finally, there is another link in the chain, for which the reader will have to take the writer's word. In 1972, I

77 ABOVE Iznik cover for a bowl, *c.*1560, from the Iznik excavations. The roundel is based on the armillary sphere of Manuel I and loose interpretations of the scroll motifs, as seen on the Chinese bowl (fig. 74). DIAM 33 cm.

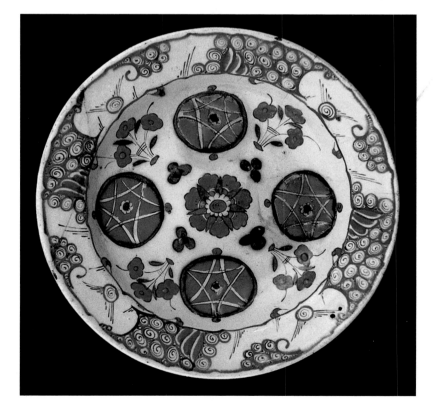

78 Iznik dish, *c.*1575, with roundels deriving from the armillary sphere design of Manuel I. DIAM 28 cm.

72

78

79 BELOW Iznik jug, *c.*1585, in underglaze blue and green, with English silver-gilt mounts marked 'I.H.' and dated 1586/7. HT 23.3 cm.

80 BELOW RIGHT Iznik jug, *c.*1585, in underglaze blue and green with black outlines, with English silver-gilt mounts. HT 20.4 cm.

purchased an Iznik bowl, in the *suq* in Damascus, which was an even more direct copy – in scale, form and decoration – of the Topkapı Chinese example. It was decorated in a grey-blue, just like the British Museum lamp discussed above. Unfortunately, the bowl was in my car when shortly afterwards the vehicle and its entire contents were stolen, in Bergamo, Italy, since when it may have graced the dinner table of an Italian crook; no trace of it has ever been seen. To conclude this circular tale, a polychrome Iznik dish, with roundels similarly composed to the blue-and-white examples, straightens out the incomprehensible motifs and turns the roundels into scarlet discs, on which intersecting arcs form a six-pointed star, resembling those on the grey-blue Museum lamp.

If the Jewish lamp and the Sino/Portuguese pottery show an

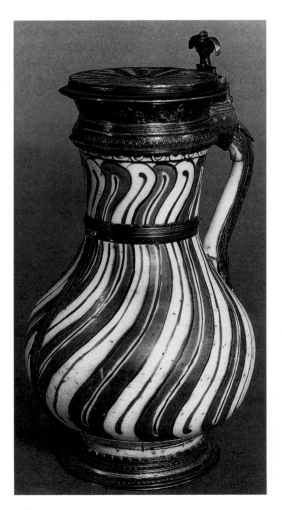

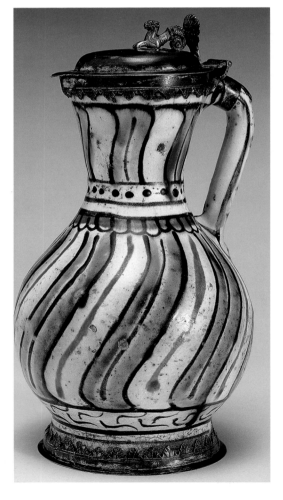

awareness of the external world on the part of the Iznik potters, this was reciprocated by the success of Iznik both within and outside the confines of the Ottoman empire. Sherds of Iznik of the highest quality, including tiles, have been discovered in the excavation of the citadel in Budapest, and there are fine examples of Iznik in the Museum of Applied Arts which may well have been imported at an early date. Iznik has also been found in Egypt, and the farthest-flung examples are sherds from the site of the Turkish garrison at Qasr Ibrim on the Nile. It was also exported in quantity across the Black Sea to southern Russia, and in particular to the Crimea. Of special importance are whole pieces of Iznik, mostly jugs, which were exported in the sixteenth century and later and which acquired European silver-gilt mounts. Not only are the mounts often dateable, thus providing a *terminus ante quem* for the objects they adorn, but they are an indication of the esteem in which Iznik was held. One such mount (which has unfortunately parted company from the jug) bears the arms of Johann Friedrich von Brandenberg, and the inscription:

Zu Nicea bin ich gemacht	In Nicaea I was wrought
Und nun gen Halle in Sachsen bracht	And now to Halle in Saxony brought
Anno 1582	In the year 1582

Mounting pottery, stoneware and porcelain was common practice in the Elizabethan era in England. There are a number of late sixteenth-century jugs with metal mounts, and at least three of them are dated by their hallmarks. The earliest, formerly on loan to the Ashmolean Museum in Oxford, is marked 'I.H.' and dated 1586/7. It is decorated with green and blue swirling petal-shaped panels, as already noted probably deriving from a repoussé metal form. A number of jugs are similarly painted, and two also have mounts. One, once in the collection of Lord St Oswald at Nostell Priory, is quite like the dated Ashmolean jug, though the mount is not marked. The other, from a private collection, was sold in 1990; it has silver-gilt mounts with a scallop-shell thumb-piece, to which is attached a bracket in the shape of a lion with a fish-tail, *lion poisson* (Fr. *lion marinière*). This much simpler mount links the jug to another, in the Victoria and Albert Museum, with a tulip and leaf design, whose undated mount also incorporates a scallop-shell.

79

80

81 The second jug with dated mounts is in the Fitzwilliam Museum in Cambridge, with a design of stylised pomegranates

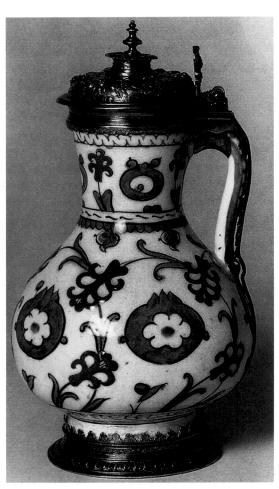

and hyacinths. Again this is marked 'I.H.' and dated 1592. Another jug with similar design and mounts is recorded, although its current whereabouts are not known, and yet another, with pewter mounts, is in the British Museum. Finally, the third dated example is a splendidly mounted Iznik jug in the British Museum, complete with a silver-gilt spout bracketed to the neck. The mounts are signed 'H.B.' and dated 1597/8. The jug is decorated with large half-palmettes intersecting on a blue ground with coral-like red touches, and there is another mounted jug with a similar design on the body in the Gulbenkian Museum in Lisbon. A cut-down jug in a private collection has a body also painted with half-palmettes and is mounted with elaborate hinged fittings in high relief, in Tudor style but probably later. They are very like the silver mounts on the five pieces of Chinese blue-and-white which once belonged to William Cecil (1520–98), Queen Elizabeth's Lord Treasurer. Known as the 'Burghley' bowls, they are now in The Metropolitan Museum of Art, New York. This silversmith's mark appears on two other pieces, dated 1585–6, and a third, 1587. Indeed, the first recorded import of porcelain ('porseland') is described in a letter from the customs surveyor in Southampton to Thomas Cromwell, stating that before the pieces are presented to Henry VIII (r. 1509–47) there should be 'certain preparations, such as chains of gold and silver . . .'. The Burghley connection is doubly interesting, for it was Cecil who was in charge of negotiations between Queen Elizabeth and Sultan Murad III, with William Harborne as the ambassador. Harborne first embarked on his mission in 1578 and by 1582 had secured the right for English merchants to trade in Turkey, which led to the establishment of the Levant Company in 1592. At what point Harborne returned

82

81 Iznik jug, *c.*1585, with English silver-gilt mounts marked 'I.H.' and dated 1592. HT 25.5 cm.

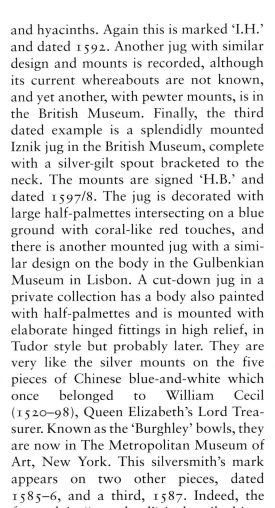

82 OPPOSITE Iznik jug, *c.*1585, with English silver-gilt mounts marked 'H.B.' and dated 1597/8. HT 31.5 cm.

to England we do not know, but there remains the intriguing possibility that not only did the Chinese porcelain return with him (for it is all of a type common in Istanbul at that time) but also some Iznik jugs as well.

However this may be, one might ask what purpose they would have served in everyday Elizabethan life. The answer, confirmed by a Frenchman in 1558, is simple: the English drank a great deal of beer. These Iznik jugs were thus transformed into beer mugs, often kitted out with metal mounts and hinged lids. One is reminded of Sir Francis Bacon's comment:

I do marvel that no Englishman, or Dutchman, or German, doth set up brewing in Constantinople, considering that they have such a quantity of Barley . . . and yet I wonder the less at it, because I see France, Italy or Spain have not taken into use Beer, or Ale, which (perhaps) if they did could better both their Healths and their Complexions.

Sylva Sylvarum, 1626

Awareness in England of the decorative qualities of Iznik ware is witnessed by a licence of 1570, granting four English gentlemen the right to manufacture 'earthen vessels and other earthen works with colours of portraictes after the matter of Turkey'. Apart from excavated sherds of Iznik from Southampton and elsewhere, and a whole plate from a latrine at Waltham Abbey, there are references to 'Turkey wares' in Walter Cope's collection in the 1590s, and in 1612 it is recorded that 'one earthen Turkey basin with painted dishes' was in the possession of a tavern-keeper in Bishopsgate. It is to be noted that the distinction is made between earthenware and contemporary imported Chinese porcelain.

As for the Continent, the clearest case for the export of Iznik ware and its influence on indigenous pottery is Italy. As the obvious maritime link between Turkey and Italy would have been Venice, it is not surprising that a tin-glazed earthenware dish from that city of *c.*1540, now in the Kassebaum collection, should with its spiralling stems and hook-like leaves betray its origin in the spiral-decorated Iznik wares. The same source can be even more distinctly observed in a Ligurian *albarello* (drug jar) 83 of about 1570. Nor was the influence only one way, for the Italian *tondino* shape of the Venetian dish, with its wide rim and deeply recessed centre, was also copied at Iznik. Medici porcelain, the 65 first European ware to approach the true composition of Chinese porcelain, was a response to the Chinese blue-and-white which

was arriving in Italy in increasing quantities from the fifteenth century onwards. Besides those items which would have simply surfaced as a result of trade with the east, there are records of diplomatic gifts, notably twenty pieces sent from the Sultan of Egypt to the Doge of Venice in 1461, and a further similar gift from the same source to Lorenzo de Medici in 1487.

It was Francesco I de Medici (1574–87) whose fascination with exotica of all sorts led to the expansion of the court workshops in Florence to include all kinds of researches into the nature of materials. This included alchemy, and just as the pursuit of the transformation of base metal into gold was to result in the discovery of the real composition of porcelain by Böttger at Dresden in the early eighteenth century, similar Florentine experiments led to the creation of a white ware combining clay from Vicenza with kaolin, known until now as 'soft-paste' porcelain but which recent analysis has shown to be in fact the real thing. Decorated in underglaze blue, the immediate source of inspiration is obviously Chinese, but it is also possible to detect the parallel influence of motifs which can only have come from Iznik, including simple sprays of flowers with carnations and tulip-like motifs, and feathery leaves. Moreover, the polychrome Iznik wares exerted their influence in turn on Italian maiolica, interpreting the Turkish patterns with a Renaissance flourish. According to the Alexandrine scholar X.A. Nomikos, who wrote a paper on the subject as early as 1924, so-called 'Candian' pottery in the Iznik style was produced at Conselves near Padua, in a monastic pottery.

To complete the circle of influence, there is a category of

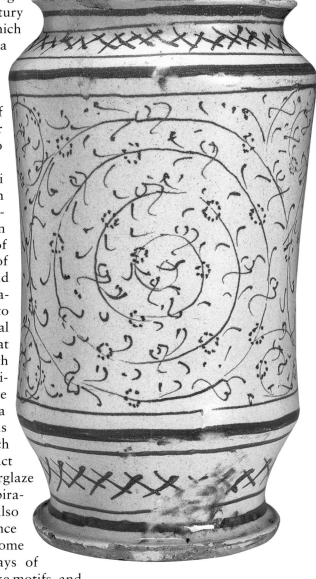

83 An Italian maiolica *albarello*, c.1570, from Liguria, with decoration in the Iznik spiral style.

91

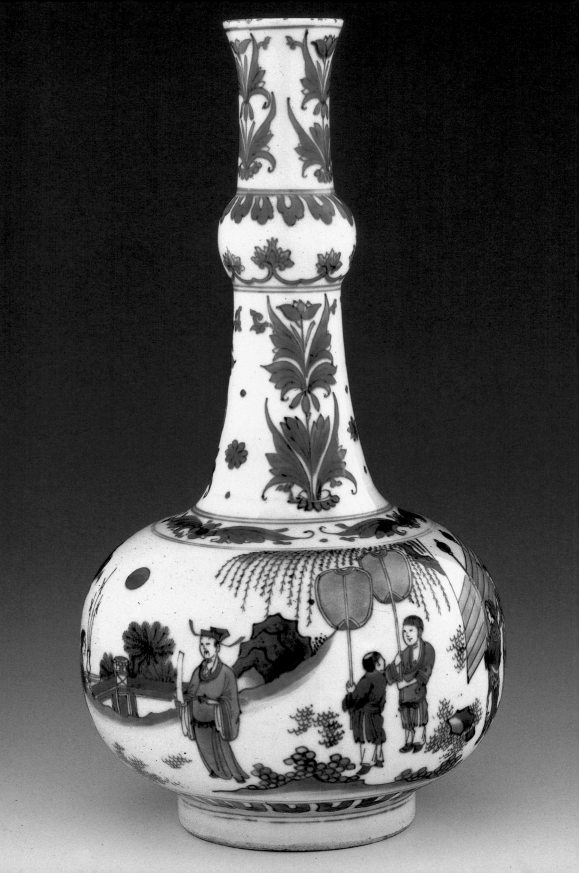

Chinese blue-and-white of the mid-seventeenth-century 'Transitional' period which shows a mysterious familiarity with the Ottoman world. Typical examples are flasks, with a pronounced bulbous moulding on the elongated neck, such as the one in the British Museum, decorated with symmetrical sprays of tulip-like flowers. The form either copies a metal *sürahi* (water-bottle) or an Iznik pottery version of the same shape, common in the sixteenth century. There is the intriguing possibility of the export of Turkish metalwork and pottery to the Far East, already noted in the context of slipware and its possible connection with Swatow. But this is an area for which so far we have no hard evidence.

84

84 OPPOSITE Chinese blue-and-white porcelain flask of the 'Transitional' period, mid-17th century, with symmetrical tulip-like sprays on the neck. HT 37.6 cm.

7

THE COLLAPSE OF THE KINGDOM

The generally accepted wisdom regarding the decline of Iznik in the seventeenth century is that it was closely linked to the slow decay of the Ottoman empire itself. Potters need patrons, and the preoccupation of successive sultans with holding on to and controlling the vast territory under their jurisdiction meant that they were more concerned with management than monuments. The most popularly quoted source for this decline is the famous Turkish traveller, Evliya Çelebi, who visited Iznik in 1648 and noted that there were only nine workshops left, compared with over three hundred at the beginning of the century. Given Evliya's known tendency to round up his figures for literary effect, his estimate of the scale of the industry during the reign of Ahmed I (1603–17) is somewhat exaggerated, but that Iznik was running downhill during his visit is not in doubt; nor is the general decline in technical quality and design of much seventeenth-century Iznik pottery.

The actual situation at Iznik was rather more subtle than simply the withdrawal of official patronage. In fact, a number of anxious *firmans*, official court directives, were issued during the reign of Ahmed I, reminding the potters of their primary obligation to keep up the supply of tiles to the capital, specifically for the Sultan Ahmed mosque, completed in 1617. This truly monumental enterprise took a decade to complete, dominating the eastern flank of the Hippodrome and acting as a counterpoise to Haghia Sophia. Vast quantities of marble and other materials went into its construction, all of which are documented along with the massive labour force employed. The Sultan managed to cajole the Venetians into providing the coloured glass for the windows. He also had an obsession with tiles, and over twenty thousand were commanded from Iznik, for which extra clay had to be secured from Kütahya and Afyon. The tilemakers were

forbidden to work for anyone else. The tiles themselves vary considerably in quality, and although some of them are finely painted, there is a repetitiousness in many of the designs and a general incoherence in the way they are used throughout the building, particularly in the galleries, where the effect is akin to wallpaper.

The completion of the Sultan Ahmed mosque marks the end of Iznik as a major supplier of tiles to the court, for when the Yeni Valide mosque was constructed on the southern side of the Golden Horn, completed in 1663, it made sparing use of Iznik tiles. Although good earlier tiles were used for the sultan's gallery, most of the tiles on the exterior are definitely of lesser quality than their predecessors. Blue and turquoise began to predominate, the patterns often confined to single tiles rather than forming part of an elaborate repeat. Characteristic of this period are single tiles with a symmetrical spray of carnations and other flowers in a vase. Lacking sufficient orders from the court, the potters turned elsewhere, and it is significant that by the mid-century large quantities of tiles were exported to Egypt. The

85

85 Iznik blue-and-turquoise tiles, c.1652, from Cairo, with simple repeating designs. Each tile 24.5 cm square.

86 Iznik dish decorated with a pagoda-like kiosk, inscribed in Greek and dated 25 May 1666 (see fig. 87). The text reads: 'O Lord, Lord, avert not thy countenance from us'. DIAM 25.8 cm.

mosque of Ibrahim Agha in Cairo, restored in AD 1652, is filled with blue-and-turquoise tiles, and similar tiles are in the Coptic church of Deir Abu Seifein in the same city. At their best, they are vividly coloured and strikingly decorative. Similar tiles were also used on part of the exterior wall of the *harem* in the Topkapı Saray. When the Sünnet Odası building, close by in the palace, was enlarged in 1641/2, such was the general dearth of tiles available that extra tile panels were reused from elsewhere to supplement the earlier original work.

Although the blue-and-turquoise tiles were to predominate, Iznik did not entirely lose its ability to work in a fuller range of colours. For instance, tiles were specially commissioned to decorate the iconostasis of the main church at Lavra, on Mount Athos. These bear Greek inscriptions and the date 1678. Although the cobalt blue, turquoise and green on the tiles is somewhat dingy, relief red is also used, and it is surprisingly bright for such a late period. These tiles point to a salient economic fact: during the seventeenth century the Iznik potters were not averse to working for non-Muslim patrons, if the commission was right. There are also a number of Iznik dishes

87 Iznik dish decorated with a wolf and boar's head, inscribed in Greek and also dated 25 May 1666 (see fig. 86). The text reads: 'O Christ our God, have mercy on the homeless'.

with Greek inscriptions on the rim, and a variety of dates including 1640, 1646, 1666, 1667 and 1678. Two dishes in the British Museum belonging to this group are intriguing on account of their subject matter. One depicts a two-storey pagoda-like kiosk with open galleries and ladders leading to the first and second floors. Hanging ornaments suggest some kind of religious structure; perhaps this is a stylisation of a *skite*, the humbler type of monastic dwelling on Mount Athos. The inscription, with the date 25 May 1666, reads:

86

ΚΗΡΙΕ ΚΗΡΙΕ ΜΗ ΑΠΟΣΤΡΕΦΙΣ ΤΟ ΠΡΟΣΟΠΟΝ ΣΟΥ ΑΦ ΙΜΟΝ
ΜΑΙΩ 25 ΕΤΟΣ 1666

O Lord, Lord, avert not thy countenance from us
May 25 year 1666.

Other uninscribed dishes have variants of the kiosk. The second dish in the British Museum, dated 19 June 1667, is painted with a plump, effeminate hand, the thumb touching the second finger as a sign of blessing, surrounded by tulips. Here the inscription reads:

ΤΟΝ ΔΕСΠΟΤΗΝ ΚΕ ΑΡΧΗΕΡΕΑΙΜΟΝ ΚΙΡΗΕ ΦΥΛΑΤΕ ΗΟΥΝΙΟ 19 1667
O Lord, protect our Lord and Archpriest, June 19 1667.

Another undated dish in the series in the Ashmolean has a more precisely Christian theme, for it shows the façade of a church with three onion-shaped domes surmounted by crosses. The inscription reads:

ΝΗΚΕΑС ΤΟ ΚΑΥΧΗΜΑ ΗΚΟΥΜΕΝΙС ΑΓΛΛΗСΜΑ ΕΤΗ . . .
The pride of Nicaea, the splendour of the inhabited world, years . . .

and thus gives the provenance of the piece.

A tile with a cross and a Greek inscription in the Topkapı Saray museum, decorated with an arched panel, was probably once part of a *sebil*, or wall-fountain. It is decorated in blue and turquoise with a well-drawn design, the spandrels filled with interlacing arabesques, and dated 1667, again indicative of the late Iznik style at its best.

To return to the dishes, even if the colours are less brilliant and the white ground dingy and crackled, the designs are often amusing and innovative. Two dishes in the Benaki Museum, also with Greek inscriptions, are in this lively style. One is dated 25 May 1666 (exactly the same date as the British Museum dish), and depicts a wolf and a grisly boar's head; the inscription reads:

86
87

ΑΗΚΕΟΧΝΙС ΗΛΙΕΝΟΗΤΕ ΧΡΗСΤΕ Ο ΘΕΟС ΗΜΟΝ ΜΑΙΩ 25 ΕΤΟС 1666

O Christ our God, have mercy on the homeless, May 25 year 1666.

The other is painted with a prancing foal. Yet more dishes have as their subjects birds, a pack-horse, a lion attacking an ox and, most unusually for Iznik, human figures, including a pair of acrobats walking a trapeze, Turkish ladies and gentlemen, a European fop, a Turkish soldier leading a captive by a rope, and a grim, mustachioed Turk with a plumed turban sitting on a flowery bank with a mace across his knees. But by far the commonest motif is of a sailing-ship, of various designs, some regularly rigged and others with lateen sails. These are a clue to one of the most important new markets for Iznik dishes in the seventeenth century, which was their purchase by Greek sailors, either at Çanakkale on the Dardanelles or in Istanbul itself. The evidence for this can be found in Lindos on the island of Rhodes, where to this day the walls of many of the houses are plated with crockery, including many pieces of Iznik. Indeed, it was this tradition which almost certainly led to the fallacy that Rhodes was the

source, and to the misnomer 'Rhodian' for what was in fact an Iznik product, which persists to this day.

Another characteristic of seventeenth-century Iznik ware was the use of supplementary gold-leaf decoration to liven up the rather dull colours. This was an Ottoman tradition, and in ceramics can be traced back at least as far as the early fifteenth century, when gold was used as additional decoration on hexagonal tiles, as in the Green Mosque at Bursa. Nor was it unknown in the sixteenth century, for a famous flask, once in the collection of the Italian tenor, Enrico Caruso, and later in the Lagonikos collection in Alexandria, was also so decorated. This fits the general aesthetic; one has only to recollect the numerous pieces of Chinese porcelain and other objects in the Ottoman royal collection which are mounted in gold and set with jewels. Never was the epithet 'gilding the lily' more appropriate than when applied to the Ottoman court.

Yet another departure during the seventeenth century was the production of tiles painted with stylised views of the Holy Places – Mecca and Medina and their attendant shrines. The Ka'ba is a favourite subject, depicted with its associated structures as a kind of primitive plan, with captions written in a crude script. These tiles are similar in style to manuscript illustrations of the same subject, serving as a point of reference for prospective pilgrims on the *hajj*. These Mecca tiles and the Iznik dishes with naturalistic designs all show an increasing awareness of the possibilities of decorating ceramics in a new way, less concerned with the dictates of the court style and more with everyday life. They are in a way akin to the manuscript illustrations of the ceremonial processions and parades of craftsmen, and to the albums of figures illustrating all ranks of Ottoman society which were produced for European travellers.

But none of these novelties was enough to sustain a vigorous industry at Iznik, and by the end of the seventeenth century it was close to collapse. This was not helped by the fact that there were now rivals. A separate tile manufactory was set up at Dıyarbakir in the sixteenth century, parallel to and echoing that of Iznik. Whether or not it was inspired by itinerant craftsmen from Iznik

88 Iznik flask, *c.*1575, in underglaze blue, green and relief red with additional gold-leaf decoration, once owned by the Italian tenor Enrico Caruso (1873–1921). HT 40 cm.

89 Syrian underglaze tiles of the second half of the 16th century, lining one of the *iwans* of the Beit Janblat in Aleppo. The decoration repeats designs and inscriptions previously used on the Dome of the Rock in Jerusalem.

we do not know. The distinctive but technically inferior tiles of the Dıyarbakir style seem only to have been used in mosques and churches in that town and in eastern Anatolia.

Further afield, the Persian potters who set up kilns in Jerusalem to produce the tiles to decorate the exterior of the Dome of the Rock in the mid-sixteenth century began to make underglaze wares during the course of their sojourn. After the work was complete, a band of potters moved to Syria, and their first noteworthy achievement was the tiling of the two *iwans* of the Beit Janblat in Aleppo, with designs close to those they had developed in Jerusalem. Whether it was this same group of crafts-men, or others who had also worked in Jerusalem, a tile industry

89

90 Syrian tile panel in the courtyard of the Dervishiye mosque in Damascus, 1574. The central panel is a lively interpretation of Iznik motifs, unusually painted on a black ground. The marbled borders contain an apple, a bird, a leaf, a crab, a parrot, a tortoise and other animals, all disguised as rocks.

sprang to life in Damascus in the second half of the sixteenth century, and in a number of buildings including the Süleymaniye mosque (1550–54), Selimiye *madrasa* (1550–70) and Dervishiye mosque and tomb (1574), Sinaniye mosque (1585) and Saʿd ad-Din *zaviye* (1574–96) the tiles show a progressive development of a highly individualistic local style. Indeed, there is often a freshness and originality in the designs which make the contemporary Iznik wares seem staid by comparison. Not that the Syrians were unfamiliar with Iznik, for imported tiles were used for the decoration of the ʿAdliye (1566–7) and Bahramiye mosque (1580–81) in Aleppo. Parallel to the Syrian tiles a pottery industry also developed, of which surviving examples are much rarer. What singles out the Syrian wares is a particular shade of green, varying from a light apple-green to a dark olive tone, quite unlike the strident viridian of Iznik pottery of the late sixteenth century. Like the decline of the Iznik industry, the work of the Syrian tile-makers became increasingly feeble in succeeding centuries, though in the eighteenth century they produced quantities of single tiles somewhat childishly painted with single cypress-trees in blue and turquoise. Syrian potters were also employed to make replacement tiles, sometimes inscribed and dated, for those that had fallen off the sixteenth-century revetments of the Dome of the Rock.

90

8

LATER

Europe had responded to Iznik pottery not only by buying it, but by making imitations. Besides blue-and-white Italian maiolica in the spiral style of the sixteenth century, polychrome copies of Iznik were made in the seven- 91 teenth century which were loose interpretations of the Iznik floral designs. These were the first external responses to the stimulus of Ottoman pottery, imitation being the sincerest form of flattery.

To return to the fate of the Iznik industry at home, in the early eighteenth century an attempt was made to revive its failing fortunes by transferring a number of workers to the capital. Two Iznik craftsmen were called in to advise on setting up a new tile factory, and by 1724 this was in operation, in the Tekfursaray district of Istanbul, just inside the walls on the south shore of the Golden Horn, close to Eyüb. This was the same area as the royal workshop created in the early sixteenth century. The tiles produced there are not likely to be confused with Iznik, for they have a discoloured ground, and the colour scheme includes dark cobalt blue, turquoise, an inferior brownish-red fading sometimes to pink, with black outlines, and two new colours, a deep green and yellow. Again, like the later Iznik tiles, the patterns tend to be confined to single tiles. They were used to decorate the Hakimoğlu 'Ali Pasha mosque (1734) at Davutpasha and a number of other mosques in Istanbul, and they can also be found in the *harem* at Topkapı Saray, the Haghia Sophia library, and on the upper part of the Ahmed III fountain (1729) just outside the entrance to the Saray.

Such was the shortage of good-quality tiles that there are numerous instances in the eighteenth century when Iznik tiles were shunted round from one location to another, and even on one occasion in 1738 brought to the capital from as far afield as Edirne. At the same time the impact of Europe began to be felt, not only by the import of Dutch tiles, many of which adorn the

harem, but also from Vienna, whence twelve crates were ordered in 1756 through the intercession of an English merchant in Galata. But more significant than any of these Western imports was the rise of the industry at Kütahya.

As we have seen, the Kütahya potteries were active at least as early as the beginning of the sixteenth century, and were in parallel production with Iznik throughout the seventeenth century. It was not until the early eighteenth century, however, that they came into their own, and began to produce tiles and pottery in a unique and distinctive style. This was largely due to the Armenian element in the ethnic background of the potters asserting itself, the Armenians like other minorities in the Ottoman empire during the eighteenth century achieving a certain autonomy. As we have observed on the two early pieces dated 1510 and 1529 which bear Armenian inscriptions, this identity was always latent, but did not become overt again until the potters produced a series of tiles and Kütahya ware during the first quarter of the eighteenth century, as votive offerings for the

91 Italian 17th-century polychrome maiolica dish, loosely interpreting Iznik floral designs.

restoration of the Holy Sepulchre in Jerusalem in 1718, with specifically Christian subjects and Armenian inscriptions. At the same time a whole range of Kütahya wares was produced: dishes, jugs, bowls, rose-water flasks, incense burners and other shapes, gaily decorated with floral patterns and carved panels in a peasant-like style somewhat akin to those used on contemporary embroidered towels. The Iznik range of colours was maintained, to which was added a bright yellow, later in the century sheering off to a more opaque mustard-like tone. Kütahya pottery supplemented the increasing quantities of imported Chinese and Japanese porcelain, and also European wares including Meissen made specially for the Ottoman market, such as coffee cups bearing the familiar crossed-swords mark on the base. Iznik was forgotten, completely eclipsed by these novelties, and virtually remaining so in Turkey almost to our own times, when a revival of interest in the Ottoman past led to a passion for collecting Iznik, much of which had long since departed for Europe and the West.

Paradoxically, just when Iznik was of least interest in Turkey itself, in the nineteenth century when the paramount fashion was for European decorative works of art, a number of foreigners began avidly to collect it. Of these, the most famous was the British Museum's ultimate major benefactor, Frederick DuCane Godman, whose superlative collection of Iznik was bequeathed by the Misses Godman in 1983. Godman first visited Istanbul in 1852, and it must have been then that his eye was caught, perhaps by the splendid tiles in the mosques. His acquisitions, however, were not made by him in the field, but at home sitting in the calm of his Victorian mansion just outside Horsham, in Sussex. His daughters have recounted how, almost every Saturday morning, dealers from the East would come trudging up the drive with their suitcases, having caught the train down from Waterloo. It became well known among the dealing fraternity that as a potential customer Godman was worth a visit. Nor did he confine his collecting to Iznik, but also acquired Persian pottery and Spanish lustreware. In this he epitomised a certain kind of Victorian taste, precisely reflected in the orientalising fantasy of a number of artists, both in England and abroad. Frederick Lord Leighton's Kensington mansion, with its interior, most notably the Arab Hall, plated with Iznik and Syrian tiles, is a supreme example. In France, Pierre Loti's house in the naval town of Rochefort, deceptively bourgeois on the outside, is a riot of tiles and tombstones, swords and Turkish textiles within. Unlike Godman, Loti knew Istanbul intimately, and his Turkish shrine is a testimony to his great love, Aziyade.

Other great collections of Iznik were formed in Alexandria, of all places, in the early part of the twentieth century. These all belonged to the wealthy Greek expatriate community who, inspired by X.A. Nomikos, an art critic, and particularly by Anthony Benaki, began to collect Islamic works of art in general and Iznik pottery in particular. The motivation for these collectors was that the spirit of Hellenism not only infused Rome and European civilisation, but also had an equal impact on the East, obviously through the campaigns of Alexander the Great and later through its influence on Coptic and Byzantine art. This culminated in the second great international exhibition of Islamic art, *L'Exposition d'Art Musulman*, held in Alexandria in 1925. Many pieces of Iznik today still bear the labels on their bases of that extraordinary exhibition, often alongside the earlier *etiquettes* of the pioneer exhibition of Islamic art at Munich in 1910. As well as Anthony Benaki, who later transferred his collection to Athens to the museum that bears his name, his cousin Alexander Benaki also collected Iznik. Among the forty-four pieces exhibited in 1925, Alexander Benaki owned seventeen, Nomikos fifteen, Lagonikos five, Salvago three, Bacos two, and Rolo and Morrisson one apiece. Anthony Benaki in fact exhibited none on this occasion, and it seems that his superlative collection was made later; he acquired many pieces from these other collectors. Mention should be made specifically of Stefanos Lagonikos, whose collection passed to his descendants and the majority of which, some forty-seven pieces, ended up in a Provençal country house, from which all but one have been dispersed over the past few years. The Lagonikos pieces are instructive, for besides the Alexandria and Munich exhibition labels, there are others which give us information about earlier owners and the history of collecting Iznik. The earliest *etiquettes* are on two dishes displayed at the National Exhibition of Works of Art in Leeds in 1868. But these pieces were mistakenly catalogued at that time as 'Persian' plates, in the maiolica section of the catalogue. The twenty dishes were lent by G.A. Durrant, FSA, SCOT., and a third dish in the Lagonikos collection actually has Durrant's own label still on it, with his heraldic device and name in Latin. Another dish belonged to Fernand Jeuniette, one of the first French collectors of Islamic art. His effects were sold at auction in 1919 after his death, and in this connection it is interesting to note that the author of the Alexandria catalogue was the French art historian Gaston Migeon, who may well have been the channel by which this dish was acquired by Lagonikos. There were fifty-one pieces of Iznik in the 1919 sale, and another example, a seventeenth-century

92 Three William de Morgan double-handled jars, decorated with floral motifs from Iznik style of the mid-16th century. Fulham period, 1888–98. HT (left to right) 35 cm; 42 cm; 31.5 cm.

dish with a stag, was acquired by Nomikos, who used the motif for his personal book-plate. This dish was in turn purchased some years later by M. Faure, the honorary Spanish consul in Egypt, and appeared in the London salerooms in 1990. It is clear from the above that the remains of labels on the backs of Iznik dishes can tell us much about their movements and are in fact part of their history, like the silver-gilt mounts of an earlier age. Actual marks on Iznik are rare. One dish has a little bird painted under the rim, and another two tulips on the base, but these seem more like a *jeux d'esprit* than potter's marks.

Interest in Iznik in the nineteenth century was not limited to a discerning group of collectors. It was also perhaps inevitable that European potters should become intrigued as well, and they began not only to manufacture straight imitations but also to use the Iznik designs to inspire their own hybrid creations. Imitations and interpretations of Iznik were produced in Italy, France, Holland, Belgium, England, Hungary and latterly even in Isfahan. Among the most interesting of these workshops were those of Theodore Deck (1823–91) and Emile Samson (1837–1913) in Paris and Ulisse and Giuseppe Cantagalli (1839–1901) in Florence, whose workshop was active from 1878 onwards. In England, the potteries at Minton, Derby and Doulton all produced such wares, and the most imaginative of all was the artist-potter William de Morgan (1839–1917), who went one step further and produced Iznik-inspired designs which were truly original.

In our own time, the fashion in Turkey for Iznik as a collectable item and the increasing public awareness of its virtues outside the limited circle of art historians, plus the impact of mass tourism, have led to a massive revival of the pottery industry, largely based on reverence for the sixteenth-century style. Paradoxically this has occurred at Kütahya, not Iznik. In the late nine-

94
93

92

teenth century the Kütahya potters began to produce a low-fired earthenware, crudely decorated but not without charm, in a primitive imitation of Iznik. When the Armenian element among the potters was extracted as a result of ethnic tensions during the formation of the new Republic, the workshops became wholly Turkish, and this was the base on which the modern industry was founded. Modern Kütahya ware is high-fired hard white ware, with all the assets of new technology. The potters themselves are convinced that they are the continuation and reincarnation of the Iznik tradition; indeed, one potter, Ismail Yiğit, is systematically working his way through the whole repertoire of Iznik masterpieces in all the world's museums, making faithful replicas. Other craftsmen are making more imaginative interpretations of

95

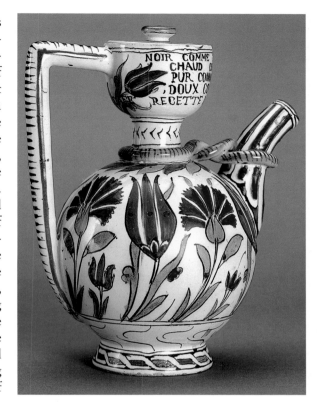

93 ABOVE Cantagalli coffee-pot decorated in Iznik style and marked with a cockerel on the base. After 1870. HT 21.5 cm. The inscription is Talleyrand's recipe for coffee:

Noir comme le diable
Chaud comme l'enfer
Pur comme un ange
Doux comme l'amour

94 LEFT Iznik-style polychrome dish by Emile Samson of Paris, *c.*1875–1900.

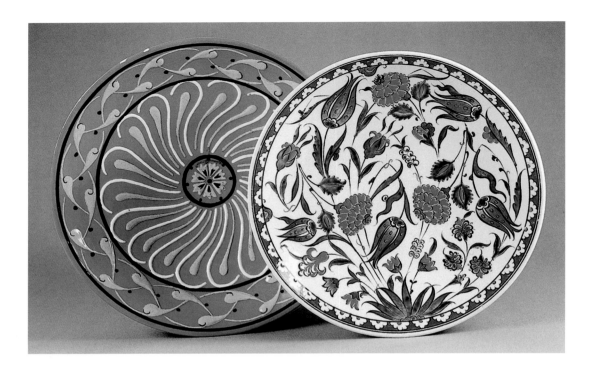

95 Two modern
Kütahya dishes made
in the early 1990s in
16th-century Iznik
style.
LEFT Slipware dish
signed by Faruk Şahin,
1991, Alopaşali Çini.
DIAM 32.5 cm.
RIGHT Polychrome
dish signed by Fikret
Aydağeli, 2 March
1992, Iznik Çini Art
Gallery. DIAM 30.5 cm.

the old designs. There is no doubt of the sincerity of their inten-
tions, which have been minutely documented by Henry Glassie.
The workshops to their credit are still very much family affairs,
and the total output is astonishing. Not only the bazaar in Istan-
bul, but every tourist outlet in the country is stacked with the
product. Less creditable are ingenious fakes of early Iznik
pottery, so cunningly devised that they are not only technically
convincing at first glance, but also demonstrate an acute aware-
ness of the authentic original designs. These are put together in
combinations that seem to imply the craftsmen are considerable
scholars. Beware.

FURTHER READING

The Age of Sultan Süleyman (exh. cat.), Art Gallery of New South Wales & National Gallery of Victoria, Australia, 1990

Aslanapa, O., *Osmanliler devrinde Kütahya çinileri*, Istanbul, 1949

Aslanapa, O., *Türkische Fliesen und Keramik in Anatolien*, Istanbul, 1965

Aslanapa, O., 'Report on Iznik', *Anatolian Studies*, 17, 1967, pp. 34–5

Aslanapa, O., 'Pottery and Kilns from the Iznik Excavations', in *Forschungen zur Kunst Asiens. In Memoriam Kurt Erdmann*, Istanbul, 1969, pp. 140–46

Aslanapa, O., Yetkin, Ş. and Altun, A., *The Iznik Tile Kiln Excavations (The Second Round: 1981–1988)*, Istanbul, 1989 (this work has an extensive bibliography, particularly important for its listing of numerous publications by Turkish scholars)

Atasoy, N. and Raby, J., *Iznik: The pottery of Ottoman Turkey*, London, 1989

Atil, E., *The Age of Süleyman the Magnificent* (exh. cat.), Washington, DC, 1987

Bacon, Sir F., *Sylva Sylvarum, or a Natural History in ten centuries*, London, 1626

Busbecq, O.G., *The Turkish Letters of Ogier Ghiselin de Busbequius*, trans. E.S. Forster, Oxford, 1927

Carswell, J., 'Pottery and Tiles from Mount Athos', *Ars Orientalis*, 6, 1966, pp. 77–90

Carswell, J., 'Six Tiles', in R. Ettinghausen (ed.), *Islamic Art in The Metropolitan Museum of Art*, New York, 1972, pp. 99–124

Carswell, J., 'Some Fifteenth-Century Hexagonal Tiles from the Near-east', *Victoria and Albert Museum Year Book*, III, London, 1972, pp. 59–75

Carswell, J., 'Syrian Tiles from Sinai and Damascus', in *Archaeology in the Levant: Essays for Kathleen Kenyon*, Warminster, 1978, pp. 269–96

Carswell, J., 'Ceramics', in Y. Petsopoulos (ed.), *Tulips, Arabesques and Turbans: Decorative arts from the Ottoman empire*, London, 1982, pp. 73–121

Carswell, J., 'The Tiles in the Yeni Kaplıca Baths at Bursa', *Apollo*, July 1984, pp. 36–43

Carswell, J., *Blue-and-White: Chinese Porcelain and its Impact on the Western World*, Chicago, 1985

Carswell, J., 'Two Tiny Turkish Pots – Some Recent Discoveries in Syria', *Islamic Art*, 2, Genoa and New York, 1987, pp. 203–16

Carswell, J., 'Kütahya Tiles and Ceramics', in *Turkish Tiles and Ceramics*, Istanbul, 1991, pp. 49–102

Carswell, J., '"The Feast of the Gods": The porcelain trade between China, Istanbul and Venice', *Asian Affairs*, 24, 2, June 1993, pp. 180–86

Carswell, J., 'C'est la Gare!', in J. Allan (ed.), *Islamic Art in the Ashmolean Museum*, 1, Oxford, 1995, pp. 99–109

Carswell, J., *Iznik Pottery for the Ottoman Empire*, Museum of Islamic Art, Qatar, 2003

Carswell, J., Hanging in suspense', *Benaki Museum 3*, 2003, Athens, 2004, pp. 177–83

Carswell, J., *Iznik Pottery and Tiles: Ottoman Ceramics in the Benaki Museum*, Athens (forthcoming)

Carswell, J. and Dowsett, C.J.F., *Kütahya Tiles and Pottery from the Armenian Cathedral of St James, Jerusalem*, 2 vols, Oxford, 1972

Covel, J., *The Diaries of Dr John Covel, 1670–79*, J. Bent (ed.), Hakluyt Society, London, 1893

Denny, W., 'Islamic Blue-and-White Pottery on Chinese

Themes', *Bulletin of the Museum of Fine Arts, Boston*, 72, 1974, no. 368, pp. 76–99

Denny, W., 'Ceramics', in E. Atil (ed.), *Turkish Art*, Washington, DC, 1980

Denny, W., 'Turkish Ceramics and Turkish Painting: The role of the paper cartoon in Turkish ceramic production', in A. Daneshvari (ed.), *Essays in Islamic Art and Architecture in Honor of Katherina Otto-Dorn*, Malibu, 1981, pp. 29–36

Fehér, G., *Craftsmanship in Turkish-ruled Hungary*, Budapest, 1975

Glassie, H., *Turkish Traditional Art Today*, Bloomington, 1993

Goodwin, G., *A History of Ottoman Architecture*, London, 1971

Krahl, R., *Chinese Ceramics in the Topkapı Saray Museum, Istanbul*, J. Ayers (ed.), 3 vols, London, 1986

Lane, A., *Later Islamic Pottery*, London, 1957

Lane, A., 'The Ottoman Pottery of Isnik', *Ars Orientalis*, 2, 1957, pp. 247–81

Lane, A., *Guide to the Collection of Tiles in the Victoria and Albert Museum, London*, London, 1960

Meinecke, M., 'Syrian Blue-and-White Tiles of the 9th/15th Century', *Damaszener Mitteilungen*, 3, 1988, pp. 203–14

Meinecke, M. and Berg, V., 'Iznik-Fleisen in Aleppo', in *Proceedings of the Fifth International Congress of Turkish Art*, Budapest, 1978

Necipoğlu, G., 'From International Timurid to Ottoman: A change of taste in sixteenth-century ceramic tiles', *Muqarnas*, 7, 1990, pp. 136–70

Necipoğlu, G., *Architecture, Ceremonial and Power: The Topkapı palace in the fifteenth and sixteenth centuries*, Cambridge, MA, 1991

Nomikos, X.A., The So-called Rhodian Ceramics [in Greek], Alexandria, 1919

Nomikos, X.A., 'The Ceramics of Candia [in Greek], Alexandria, 1924

Otto-Dorn, K., *Türkische Keramik*, Ankara, 1957

Otto-Dorn, K. and Anhegger, R., *Das Islamische Isnik*, Berlin, 1941

Porter, V., *Islamic Tiles*, London, 1995

Raby, J., 'A Seventeenth Century Description of Iznik-Nicaea', *Deutches Archäologisches Institut Abteilung Istanbul, Istanbuler Mitteilungen*, 26, 1976, pp. 149–88

Raby, J., 'Diyarbakir: A Rival to Iznik: A sixteenth-century tile industry in Eastern Anatolia', *Deutches Archäologisches Institut Abteilung Istanbul, Istanbuler Mitteilungen*, 27/28, 1977–8, pp. 429–59

Raby, J. and Tanındı, Z., *Turkish Bookbinding in the 15th Century: The foundation of the Ottoman court style*, T. Stanley (ed.), London, 1993

Raby, J. and Yücel, Ü., 'Blue-and-White, Celadon and White Ware: Iznik's debt to China', *Oriental Art*, 29, 1983, pp. 38–48

Raby, J. and Yücel, Ü., 'The Archival Documentation', in Krahl, R., *Chinese Ceramics in the Topkapı Saray Museum, Istanbul*, J.Ayers (ed.) 3 vols, London, 1986, pp. 27–54

Raby, J. and Yücel, Ü., 'Chinese Porcelain at the Ottoman Court', in Krahl, R., *Chinese Ceramics in the Topkapı Saray Museum, Istanbul*, J. Ayers (ed.) 3 vols, London, 1986, pp. 65–96

Riefstahl, R.M., 'Early Turkish Tile Revetments in Edirne', *Ars Islamica*, 4, 1937, pp. 241–89

Rogers, J.M., 'The Godman Bequest of Islamic Pottery', *Oriental Art*, July 1984, pp. 24–31

Rogers, J.M., 'A Group of Ottoman Pottery in the Godman Bequest', *Burlington Magazine*, March 1985, pp. 134–44

Rogers, J.M., *Empire of the Sultans: Ottoman art from the collection of Nasser D. Khalili*, Geneva and London, 1995

Rogers, J.M. and Ward, R.M., *Süleyman the Magnificent* (exh. cat.), London, 1988

Şahin, F., 'Kütahya seramik teknologisi ve çini fırınları hakkinda görüşler', *Sanat Tarihi Yilliği*, 11, 1981, pp. 133–51

Şahin, F., 'Kütahya-da çinili eserler', *Atatürk'ün Doğumunun 100. Yılına Armağan*, Istanbul, 1981–2, pp. 111–70

Skilliter, S., *William Harborne and the Trade with Turkey, 1578–1582*, Oxford, 1977

Soliman le Magnifique (exh. cat.), Grand Palais, Paris, 1990

Tite, M.S., 'Iznik Pottery: An investigation of the methods of production', *Archaeometry*, 31: 2, 1989, pp. 115–32 (this includes an analysis of the sherds excavated by F. Şahin)

Wenzel, M., 'Early Ottoman Silver and Iznik Pottery Design: Animal style', *Apollo*, 135, 1989, pp. 159–60

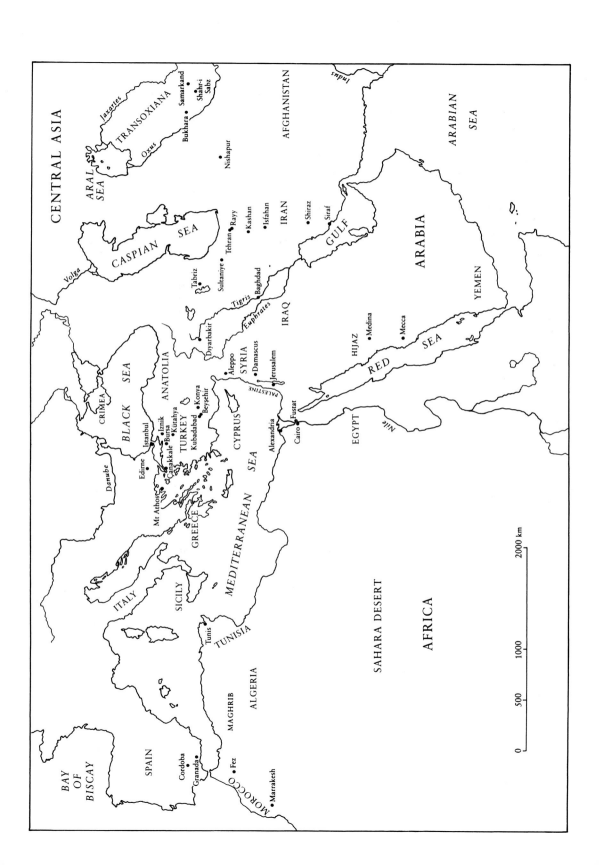

ILLUSTRATION ACKNOWLEDGEMENTS

Accession numbers of objects in the British Museum are prefixed by the departmental designation OA *(Oriental Antiquities). Photography by the British Museum Photographic Service unless otherwise noted.*

FRONT COVER OA G.1983.48, Godman Bequest
FRONTISPIECE OA G.1983.122, Godman Bequest
1–4 Photos by author
5–6 Photos by Selamet Taşkin
7 Photo by author
8 OA 1937.10-12.1
9–10 Photos by author
11 Iznik excavations, 83/13; photo courtesy O. Aslanapa
12 Courtesy Sadberk Hanım Museum, Istanbul, HK.38.3101; photo by Selamet Taşkin
13 Nihal Kuyaş Collection, Davos; photos by Sotheby's
14 Courtesy Topkapı Saray Museum, Istanbul, TKS 15/1383; photos by Sotheby's
15 Courtesy Musée du Louvre, Paris, 6321; ©Photo RMN: H. Lewandowski
16 Photo by Sotheby's; drawing by author
17 Courtesy Benaki Museum, Athens, 17098; photo by author
18 Photo by author
19 OA G.1983.7, Godman Bequest
20 Courtesy Union Centrale des Arts Décoratifs, on loan to Musée du Louvre, Paris, 8062; photo La Licorne
21 Inebey Library, Bursa; photo by Reha Günay, courtesy Azimuth Editions, London
22 Photo by Sotheby's
23 OA 1937.10-12.1
24 OA G.1983.1, Godman Bequest
25 OA G.1983.18, Godman Bequest
26 OA 1878.12-30.519, Henderson Bequest
27 OA 1968.04-22.27
28 OA 1878.12-30.521 & 522, Henderson Bequest
29 OA G.1983.52, Godman Bequest
30 OA G.1983.8, Godman Bequest
31 Courtesy Topkapı Saray Museum, Istanbul; photo by Selamet Taşkin

32 Courtesy Museum für Islamische Kunst, Staatliche Museen zu Berlin, J.4201; photo ©Bildarchiv Preussischer Kulturbesitz, Berlin/Jürgen Liepe, 1997
33 Courtesy The Metropolitan Museum of Art, New York, 14.40.727; photo by author
34 Courtesy Topkapı Saray Museum, Istanbul; photo by Selamet Taşkin
35 Courtesy Benaki Museum, Athens; photo by author
36 OA G.1983.3, Godman Bequest
37 OA G.1983.34, Godman Bequest
38 OA 1878.12-30.530, Henderson Bequest
39 OA 1887.5-16.1
40 OA 1887.5-16.1
41 Courtesy Musée National de la Renaissance, Ecouen, E.CL.9419; ©Photo RMN: Gérard Blot
42 Courtesy Benaki Museum, Athens, 9; photo by author
43 OA G.1983.42, Godman Bequest
44 OA G.1983.21, Godman Bequest
45 OA G.1983.66, Godman Bequest
46 Photo by author
47 Drawings by author
48 Photo by author
49 Photo by Simon Upton, courtesy *Cornucopia*
50 Photo by author
51 Lagonikos Collection, Alexandria; photo by Sotheby's
52 Photo by Godfrey Goodwin
53 OA 1878.12-30.497
54 OA 1878.12-30.482
55 OA G.1983.46
56 OA FB.154, Franks Bequest
57 OA 1878.12-30.485
58 OA 1878.12-30.494
59 OA G.1983.152
60 OA G.1983.102
61 OA G.1983.31, Godman Bequest
62 Lagonikos Collection, Alexandria; photo by Sotheby's
63 Musée du Louvre, Paris, AA 403; ©Photo RMN
64 Private collection; photo by Sotheby's
65 OA G.1983.163, Godman Bequest
66 Photo courtesy Ashmolean Museum, Oxford, 1978.1455
67 OA G.1983.14, Godman Bequest
68 Courtesy Magdalen College, Oxford, Lt-Col. R.H. Brocklebank Bequest

69 Courtesy Calouste Gulbenkian Foundation Museum, Lisbon, 2240
70 OA 1878.12-30.466, Henderson Bequest
71 OA G.1983.80, Godman Bequest
72 OA G.1983.122, Godman Bequest
73 Private collection, Istanbul; photo by Sotheby's
74 Courtesy Topkapı Saray Museum, Istanbul, TKS 15/2254; photos by Sotheby's
75 After Carswell, *Blue-and-White*, p. 155
76 Courtesy Sadberk Hanım Museum, Istanbul, 9513-p.373; photo by Selamet Taşkin
77 Iznik excavations, Bhd E-H Mb10; photo by author
78 Courtesy Sadberk Hanım Museum, Istanbul, 3944-HK.881; photo by Selamet Taşkin
79 Private collection; photo courtesy Ashmolean Museum, Oxford (on loan)
80 M. Simeon Collection; photo by Sotheby's
81 Courtesy Fitzwilliam Museum, Cambridge, M.16-1948
82 OA AF.23
83 Private collection, London; photo by Sotheby's
84 OA F.1676
85 Private collection; photo by Sotheby's
86 OA 1887.2-11.3
87 Courtesy Benaki Museum, Athens, EC.61/25; photo by author
88 Lagonikos Collection, Alexandria; photo by Sotheby's
89–90 Photos by author
91 Private collection; photo by Sotheby's
92 Private collections; photo by Sotheby's
93 Photo by Sotheby's
94 OA 1907.06-12.3
95 Private collection, London; photo by Sotheby's

INDEX

Numbers in *italic* refer to figure numbers and captions.

Abraham, deacon, son of potter (*tchiniji*) 48
Abraham of Kʿotʿay (Kütahya) 46
Abu'l Qasim, treatise 24, 30
ʿAdliye mosque, Aleppo 113
Adrianopolis 18
Afrasiyab 30
Afyon 106
Ahmed I, Sultan (1603–17) 84, 106
Ahmed III, Sultan (1703–30), fountain 114
albarello 83, 83, 103
alchemy 103
Aleppo 112–13
Alexander the Great 117
Alexandria 53, 57–8, 78, 81, 105, 111, 117
ʿAli ibn Ilyas ʿAli (Nakkaş ʿAli) 15–16
Alopaşali Çini, Kütahya 95, 120
analysis of Turkish pottery 30–32, 48
Anatolia 10, 13, 28, 111
animal-style decoration 65, 85
Ankara 47
Antioch 29
Aq Sarai palace, Shahr-i Sabz 15
Armenian Cathedral of St James, Jerusalem 10, 11
Armenian: craftsmen 48; inscriptions 12, 22, 24–5, 45–8, 115; in Kütahya 48, 115–16
armillary sphere 74–8, 95–7
Ashmolean Museum, Oxford 99
Atasoy, Nurhan 12

Ataturk, Mustafa 13
Athens 17, 51, 68, 117
Aydağeli, Fikret 95, 120
Aziyade 116

Bacon, Sir Francis 102
Bacos 117
Bahramiye mosque, Aleppo 113
Balkans 18
Balkan silver 33, 36, 41, 55, 84
Bayezid (son of Sultan Süleyman) 95
Bayezid II, Sultan (1481–1512) 39, 92; *türbe* 37
beer 102
Beit Janblat, Aleppo 89, 112
Belgium 118
Bellini, Gentile 26
Benaki, Alexander 117
Benaki, Anthony 117; his museum 50–51, 68, 110
Bergamo 98
Berlin 51, 59
Beyişehir, Lake 28
Bishopsgate 102
Black Sea 99
bookbinding 38–40
book design 50
Böttger, Johann Friedrich 103
von Brandenberg, Johann Friedrich 99
Brocklebank, Lt-Col. R.H., collection 68, 88
Bronze Age 13
Budapest 99
Buddhist symbols 32–3
'Burghley' bowls 100
Bursa 2–4, 14–17, 23–4, 25–7, 36, 38, 47–8, 71–3, 89, 111
Busbecq, O.G. 74
Byzantine art 117

Byzantium 13, 14, 28, 43

Cairo 85, 107–8
'Candian' pottery 103
Çannakale 110
Cantagalli, Ulisse and Giuseppe 93, 118
Caruso, Enrico 88, 111
Çatal Hüyük 13
Cecil, Lord William 100
celadon 12, 12, 29, 36, 51, 59, 62, 63, 82, 91, 92
Çelebi, Evliya 106
Çem Sultan, *türbe* in Bursa 26
Central Asia 10, 13, 15, 16, 30
China 10, 16, 33, 41, 90–105; lacquer 16; painting 16; silk 16
Chinese porcelain 7, 30, 63, 102, 105, 111, 116; blue-and-white 8, 12, 14, 16, 21, 24, 25, 29, 32, 36, 51, 51, 53, 54, 59, 62, 63, 82, 84, 85, 87, 91, 95, 100, 103, 105; celadon 12, 12, 29, 51, 59, 62, 63, 82, 91, 92; *lianzi* bowls 35, 62; lobed-leaf motif 21; provincial ware 89; reign-marks 85, 87; 'Transitional' ware 105
Çinili Kiosk, Topkapı Saray 10, 27
Çintimani 83, 91
Circumcision Chamber *see* Sünnet Odası
Conselves 103
Constantinople 14, 24, 29, 102; *see also* Istanbul
Cope, Walter 102
Coptic art 117
Covel, Dr John 43–4

craftsmen 14, 16, 18, 26, 38, 43, 48, 91, 111
Crimea 99
Cromwell, Thomas 100
cuerda seca tiles 2, 4, 14, 16, 24, 26, 73
Cyprus 28

Dalmatia 83
Damascus 24, 98; tiles 24, 90, 113
Dardanelles 110
Davutpasha, Istanbul 114
Deck, Thomas 118
Deir Abu Seifein, Cairo 108
De Morgan, William 92, 118
Derby 118
Dervishiye mosque and tomb, Damascus 90, 113
Diyarbakir 111
Dome of the Rock, Jerusalem 67, 71, 73, 76, 112, 113
Doulton 118
Dowsett, Charles 12, 48
Dresden 103
Durrant, G.A. 117
Dutch 102; tiles 114

earthenware 11, 13, 28, 29, 30, 32
Ecouen 63, 76
Edirne 14, 18, 23–4, 25–7, 30, 51, 89, 115; Murad II mosque 5–7, 18–24; Saray 18; Selimiye mosque 52, 78–80; Üç Şerefeli mosque 9, 24–5, 26
Egypt 12, 17, 31, 99, 107, 117; Sultan of 103
Elizabeth I 99, 100, 102
Eşrefzade Rumi (Iznik) 66
Europe 10, 13; civilisation 117; coat-of-arms 83; travellers 111
Exposition d'Art Musulman, Alexandria 117
Eyüb 114

Fakhr al-Din al-Razi, *Mafatih al-ghayb* 21, 40
Far East 105
Fatih Cami (mosque), Istanbul 27
Faure, M. 118
firmans 50
Fitzwilliam Museum, Cambridge 99

Florence 103, 105, 118
France 102, 118
fritware, Iznik 30

Galata 115
Gebze 51
German 102
glass 16, 50, 106
Glassie, Henry 82, 120
Godman, Frederick DuCane 9, 116; collection 12, 45, 116; ewer 24, 45–6; water-bottle 25, 45–7
Golden Horn, Istanbul 56, 75, 107, 114
'Golden Horn' style pottery 25–6, 48–51
gold-leaf decoration 88, 111
Gray, Basil 11–12
Greeks 13; inscriptions 86–7, 108–10; Greek Patriarch in Istanbul 95; sailors 110; stamp 22
Green Mosque, Bursa *see* Yeşil Cami
Green Tomb, Bursa *see* Yeşil Türbe
Gulbenkian Museum, Lisbon 100

Habib, potter 58
Haghia Sophia 106; library 114
Hakimoğlu ʿAli Pasha mosque, Istanbul 114
Halle 99
hanging-lamps *see* Iznik pottery
Harborne, William 100
harpies 28
Hasseki Hürrem (Roxelane): *imaret* 73; tomb 75–6
Hebrew lamp 73, 94–5
Hellenism 117
Henry VIII 100
Hippodrome, Istanbul 106
Hittites 13
Holland 118
Holy Mother of God monastery, Ankara 47
Holy Sepulchre, Jerusalem 116
homarcui (Omerli Köy, near Kütahya) 43
Hungary 118

Ibrahim I, Sultan (1640–48) 58
Ibrahim Agha mosque, Cairo 108
Ibrahim Pasha mosque,

Silivrikapı 46, 70
Ibrahim Pasha Museum, Istanbul 12
Ice Age 13
inscribed pottery and tiles 2, 4, 9, 15, 16, 18, 25, 32, 33, 37, 38, 39–40, 46, 48, 52, 65–7, 71–3, 73, 79, 86–7, 89–90, 94–5, 108–10, 112, 113, 116
Isfahan 118
Islam 13; *see also* Muslims
Islamic metalwork 37
Istanbul 10, 12, 31, 34, 46, 48, 51, 56–7, 61, 63, 70, 94, 95, 114, 116, 120; *see also* Constantinople
Italy 50, 83, 98, 102, 118
Iznik 1, 10; analysis 30, 32; excavations 11, 32, 77, 97; fakes 120; fritware 30–32; holes drilled in footring 55; kilns 32; marks 118; sherds 17, 35, 37, 62, 99; slipware 29–30, 63, 68, 89
Iznik pottery 9, 24; bowls on pedestal foot 30, 32, 37, 45, 50, 54–5, 68–70; candlesticks 16, 28, 32, 36, 51, 83; cover 77, 97; covered bowls 61, 82–3; dishes 15, 20, 27, 29, 32, 32–3, 37, 37–8, 38–9, 41, 43–4, 50, 53–60, 54–5, 59, 65, 68–9, 68–9, 71, 76, 76, 78, 82, 83, 85, 86–7, 89, 99; earthenware 11, 13; ewer 83; flasks 26, 32, 36, 50, 54, 70, 88, 91, 105, 111; hanging-lamps 23, 32, 37, 38, 39–40, 41, 43, 45, 65–7, 72–3, 76, 91, 92, 94, 99; hanging ornaments 32, 36, 37, 42, 67–8, 76, 109; jars 32, 36, 36, 62–3; jugs 37, 62, 79–82, 83, 85, 89, 99, 100, 102; *matara* (water-vessel) 64, 84; pen-box 19, 32, 37–8; pilgrim-flask 36; tankards 50, 54, 63, 68, 83, 84, 85; tiles 9, 18, 31, 38, 46–50, 50, 52, 70–80, 85, 106–8; vases 53, 85
Iznik Çini Art Gallery, Kütahya 95, 120

Janissary corps 14
Japanese porcelain 116
Jerusalem 10–11, 36, 67, 73, 112, 116

Jeuniette, Fernand 117–18
Jewish community, in Istanbul 95

Kaʿba 111
kaolin 105
Karamürsel 48
kaşihane (ceramic workshop) 58
Konya 13, 28
Kubadabad, palace 28
kufic inscriptions 3, 15, 25, 36, 37
Kütahya 10, 12, 106; pottery 11, 24–5, 30, 86–8, 115–20; and Iznik 45–54; modern industry 82, 95, 119–20

lacquer 16
Lagonikos, Stefanos 117
Lagonikos collection, from Alexandria 53, 57–8, 76, 88, 111, 117–18
Lane, Arthur 10–12, 45, 48
Lavra monastery, Athos 108
leather forms 83–4; doublures 21, 39
Leeds 117
Leighton, Frederick Lord 116;
Leighton House, Kensington 116
Levant Company 100
lianzi bowls 35, 62
Liguria 103
Lindos 110
Lisbon 91, 100
Loti, Pierre 116
Louvre, Musée du, Paris 32–3

maiolica, Italian 50, 83, 91, 105, 114, 115
Mamluks 16, 36; metalware 37
Manuel I, of Portugal 74–5, 95, 96
manuscript illumination 32, 38, 50
Marmara, Sea of 48, 63
matara (water-vessel) 84
Mecca 67, 111
Medici: Francesco I de 103; Lorenzo de 103; porcelain 102
Medina 67, 111
Mehmed I, Sultan (1413–21) 4, 14, 16
Mehmed II, Sultan (1444–6; 1451–81) 14, 24, 26–7
Meissen 116

Mellaart, James 13
Mesopotamia 28
Metropolitan Museum of Art, New York 59, 76, 100
Mevlevi sect 18
Migeon, Gaston 117
Mihrimah, Princess, daughter of Sultan Süleyman 74
'Miletus' ware 11, 29, 32
minai pottery 28
Ming dynasty (1368–1644) 12, 21, 29, 38
Minton 94, 118–19
Mongols 16
Morrisson 117
Mount Athos 108, 109
Muhammad Khan (Sultan Mehmed I) 24
Muhammad al-majnun ('the Mad'), tilemaker 16
Munich 117
Murad I, Sultan (1360–89) 14
Murad II, Sultan (1422–44; 1446–51); mosque at Edirne, 5–7, 18–24; painted inscription 7, 21
Murad III, Sultan (1574–95) 100
Murad IV, Sultan (1623–40) 84
Musée de la Renaissance, Château d'Ecouen 63, 78
Museum of Applied Arts, Budapest 99
Musli, potter 39–40, 43–5, 66–8, 71
Muslims 91; see also Islam
Mustafa Pasha, tomb at Gebze 51

Nakkaş ʿAli see ʿAli ibn Ilyas ʿAli
nakkaşhane (court designers) 32, 56, 63, 78
Nasi, Don Joseph 95
National Exhibition of Works of Art, Leeds 117
Near East 14
Necipoğlu, Gülru 56
Nicaea (ancient Iznik) 10, 99, 110
Nile river 10, 99
Nilüfer Hatun museum, Iznik 88
Nishapur 30
Nomikos, X.A. 103, 117
North Africa 13
Nostell Priory 99
Nubia 10

Omerli Köy (near Kütahya) 43
Osman 13
Osman II, Sultan (1618–22) 84
Ottoman Empire 9, 13, 14; archives 9; early ceramics 13–28; society 111
Oxford 99

Padua 103
Paris 63
Pero da Faria, Captain of Malacca 74, 95–6
Persia 24, 28, 30, 73, 112; pottery 116
pewter mounts 100
Pope, John 59
porcelain see Chinese porcelain
Portuguese 95–6, 97, 98
Privy Chamber, Topkapı Saray 59

Qasr Ibrim 99
Qur'an 37, 39, 66, 78

Rabbi, Chief, in Istanbul 95
Raby, Julian 12, 41
Rhodes 110
'Rhodian' ware 50
Rochefort 116
Rolo 117
Roman Empire 13
Roxelane see Haseki Hürrem
Rum 13
Russia 13, 99
Rüstem Pasha, Grand Vizier 73, 74; mosque, Istanbul 49–50, 74–6

Saʿd ad-Din zaviye, Damascus 113
Şahin, Faruk 95, 120
Şahkulu 56–8
sailing-ships 110
St James Armenian Cathedral, Jerusalem 10–11
St Oswald, Lord 99
Salonika 89
Salvago 117
Samarkand 15, 30
Samson, Emile 118, 119
Saray, Edirne 18
Saxony 99
Şehzade Mahmud, son of Bayezid II, tomb in Bursa 18, 36–8
Şehzade Mehmed, son of Sultan Süleyman, tomb of 73

Selim I, Sultan (1512–20) 56
Selim II, Sultan (1566–74) 95
Selim III, Sultan (1789–1807)
 19, 37, 38
Selimiye *madrasa*, Damascus
 113
Selimiye mosque: Edirne 52,
 78–80; Istanbul 73
Seljuks 13, 28; pottery 28
Serbia 83
sgraffiato pottery 28, 30
Shah-i Zindah 15
Shahr-i Sabz 15
Silivrikapı, Istanbul 46, 70–71
silk 16
silver-gilt: bowl 13, 33; mounts
 70, 79–82, 91, 98, 99, 100,
 101, 102, 118
silver marks: 'H.B.' 100; 'I.H.'
 99, 100
Sinan 70, 71, 74–5, 78
Sinaniye mosque, Damascus 113
Sirkeci (Post Office site),
 Istanbul 35, 50, 62
Song dynasty (960–1279) 62
Sotheby's 36
Soustiel, Joseph 59
Southampton 100
Spain 14, 95; consul in Egypt
 118; lustreware 116
Stambol *see* Istanbul
star-and-cross tiles 28
Süleyman, Sultan (1520–66) 13,
 33, 51, 58, 63, 67, 71, 74;
 tomb of 76

Süleymaniye mosque: Damascus
 113; Istanbul 74–6
Sultan Ahmed mosque, Istanbul
 106, 107
Sünnet Odası (Circumcision
 Chamber), Topkapı Saray 31,
 34, 56–9, 60–62, 108
Swatow 89, 105
Sylva Sylvarum 102
Syria 12, 14, 16, 24, 28, 30,
 112; tiles 89–90, 112–13, 116

Tabriz 16, 26; craftsmen 24, 26,
 56
tadpoles 37, 38, 51, 53
Tahtakale, Istanbul 74
Talleyrand, Count 93, 119
al-Tawrizi, Ghars ad-Din Khalil
 24
Tekfursaray, Istanbul 56, 114
Tēr Martiros, Bishop 47
Testaments, Old and New 10
thuluth inscriptions 3, 16, 25
Timur 15, 16
Timurid decoration 16, 38
Timurtaş *hammam* (baths),
 Bursa 73
tombak (gilt copper) 83
Topkapı Saray, Istanbul 26, 27,
 29, 32, 36, 37, 58, 62, 87, 89,
 96, 97, 108, 110, 114; Çinili
 Kiosk 10, 27; *harem* 108,
 114; inventories 24; Privy
 Chamber 59; Sünnet Odası
 31, 34, 56–9, 62, 108

Tudor 100
tuğras 13, 19, 33, 37, 50, 84
tulips 59
Tunça river 18

Üç Şerefeli mosque, Edirne 9,
 24–5, 26
Umayyad dynasty 14
Usta ʿAli, potter 58

Valledeh jamy (Yeni Valide
 Cami) 45
Venice 102–3; Doge 103;
 earthenware 102; glass 50,
 106
Vicenza 105
Victoria and Albert Museum,
 London 10, 50, 76, 99
Vienna 59; tiles 115

Waltham Abbey 102
Waterloo 116

Yeni Kaplıca *hammam* (baths),
 Bursa 47–8, 71–3, 89
Yeni Valide mosque, Istanbul 43,
 107
Ye'il Cami (Green Mosque),
 Bursa 2–3, 14–18, 20, 111
Ye'il Türbe (Green Tomb), Bursa
 4, 14, 16–20
Yuan dynasty (1271–1368) 12,
 12, 14, 21, 25, 29, 32, 36, 38,
 59, 62, 63, 82, 92